DONCASTER AT WORK

PAUL CHRYSTAL

AMBERLEY

Front cover: Doncaster power station in 1957, taken from St Mary's Bridge, looking west. (Photo taken by the late Leonard McKone)

Back cover: Wreckage from a runaway train at Clayton West in October 1919.

First published 2019

Amberley Publishing
The Hill, Stroud
Gloucestershire, GL5 4EP

www.amberley-books.com

Copyright © Paul Chrystal, 2019

The right of Paul Chrystal to be identified as the Author of this work has been asserted in accordance with the Copyrights, Designs and Patents Act 1988.

ISBN 978 1 4456 8591 5 (print)
ISBN 978 1 4456 8592 2 (ebook)

British Library Cataloguing in Publication Data. A catalogue record for this book is available from the British Library.

Typesetting by Aura Technology and Software Services, India. Printed in the UK.

CONTENTS

Introduction 4

Coaching Days, Rivers and Canals 7

The Coalfields 9

Doncaster Iron and Steel 27

The Railways 31

Confectionery 39

Other Doncaster Industry and Business 44

Tourism and Leisure 70

Doncaster at Work in the Twenty-first Century 73

Conisbrough 74

Mexborough 86

About the Author 96

INTRODUCTION

In 1828 Joseph Hunter wrote of a 'wealthy and truly beautiful town'. In 1837 William White described a town where 'The streets are generally spacious and well built, and contain many handsome houses and elegant public edifices.' The following year Dr. T. F. Dibdin wrote, 'Of all the towns I have entered on the continent or in England, I am not sure that I was ever so impressed with the neatness, the breathing space, the residence-inviting aspect … it is cheerful, commodious, and the streets are of delightful breadth. You need not fear suffocation, either from natural or artificial causes for no smoke is vomited from trailing column from manufacturing chimneys. The sky is blue, the sun is bright, the air is pure.' The Revd J. G. Fardell, rector of Sprotbrough, described 'one of the most striking and beautiful of England's towns' in 1850.

Halcyon days indeed, and shades of Arcadia. Are these sun-drenched lands familiar? No, not many people would recognise this as Doncaster, a town which then seems to have had more than its share of wealthy residents who were attracted by the absence of heavy industry, the plethora of fine houses and an inexpensive and abundant supply of provisions. Indeed, in the late 1830s, one resident felt compelled to write 'there are but few towns in the Kingdom in which so great a portion of the inhabitants are possessed of independent fortunes'. Obviously, Doncaster also had its share of slums and disgusting living conditions, inequality and poverty, but it had affluence and a healthy standard of living could be enjoyed there by some. It was however, indisputably, a typical English market town with a market-town economy and market-town people.

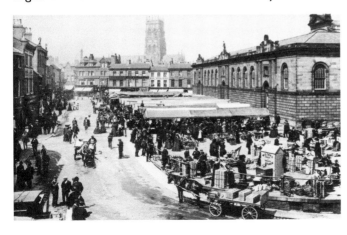

Doncaster market.

When country came
to town.

It was the Romans who were the first to bring organised work and industry to Doncaster with a lengthy public works programme including public buildings, private housing and roads. The military was obviously a major employer here too with troops building and garrisoning army buildings. Daniel Defoe saw this, in his *A Tour thro' the Whole Island of Great Britain* (1724–27), when he came to Doncaster and wrote nostalgically that, 'Here we saw the first remains of the great Roman highway, which, though we could not see before, were eminent and remarkable just at the entrance into the town, and soon after appeared in many places.'

Later, he visited Wakefield:

From Wakefield we went to see the ancient town of Pontefract; but rode five or six miles out of our way over Barnsdale in order to see the great Roman causeway which runs across the moor from Doncaster to Castleford. It runs in a line from Doncaster to Castleford where it tuns off at an angle, and runs in another direct line to Aberford, Tadcaster, and York.

Doncaster (or Danum to give it its Roman Latin name) was strategically important to the Romans because it provided a crossing point from the road from Lincoln over the Don to York and the north when the usual ferry crossing at Winteringham via the main route of Ermine Street was not an option due to adverse weather. Furthermore, it occupied the border between the troublesome Brigantes north of the river, and the comparatively peaceful and Romanised Coritani to the south.

Much of Roman Doncaster languishes under modern buildings, not least St Sepulchre Gate. Excavations here, south of the fort, have uncovered the western defences of the civilian settlement or *vicus*, which would have supported a myriad of industries and businesses, arming, feeding, clothing and entertaining the garrison.

The Roman fort was on the site now covered by St George's Minster, next to the River Don. Excavations in 1969 revealed this to be a Trajanic/Hadrianic (AD 98–138) fort with defences that were originally of clay and gravel, which was strengthened in the late Antonine era (AD 130–180). These defences overlay an earlier Roman timber building – a larger Flavian (AD 69–96) fort of greater dimensions than the later known fort – which was demolished to allow for its successor to be built on the same site.

Fast forward to the late eighteenth century and Doncaster Corporation tried in vain to develop industry in its town; indeed this was limited to workhouse inmates who had no work. In 1747 they set up a cutlery workshop, bringing a cutler from Sheffield to train the

workhouse inmates. A worsted manufactory came next in 1758, for which a manufacturer was shipped in from Bradford, but this too failed. Finally, in 1771 a sacking and sackcloth manufactory was set up.

The industrial landscape was to change dramatically in the next century when coal deposits were exploited in the vicinity and steelmaking and railway engineering formed the career paths for many of the town's residents, mainly work-hungry immigrants from other parts of the United Kingdom.

In the early railway age the town was transformed by coal and the railways and associated industries, and between 1851 and 1901 Doncaster's population grew from 12,967 to 39,404. The seismic change meant that country town Doncaster was now an industrial centre of some note.

This book charts and explores the work and industry that has characterised Doncaster down the years, and which shapes the town today in the early twenty-first century. The River Don and the Don Navigation can claim part of the responsibility for the town's pre-eminence as a coal mining, steel and railway manufacturing centre. Over time, such famous industrial names as Rockware Glass, DuPont, chemical polymers producers, and Bridon Ropes, wire rope manufacturers, have helped make Doncaster a major industrial centre. In the nineteenth and twentieth century Doncaster was an important confectionery town, famous as inventors of butterscotch and producers of brands like Nuttalls Mintoes from Parkinson's.

When the railways came to Doncaster, Great Northern Railway opened the Doncaster Locomotive and Carriage Building Works to take advantage of Doncaster's excellent communication links; Wabtec continues to do railway stock refurbishment in the town. Doncaster PSB is one of the largest signalling centres in the UK, while Doncaster International Railport is a vital road-rail intermodal terminal. The rail freight company DB Cargo UK is headquartered in Doncaster.

As elsewhere, the Second World War had a huge impact on the industrial and workforce landscape. By 1943, 37 per cent of the female workforce in South Yorkshire made munitions. Women could not be employed in underground mines because of a law introduced in 1842 that forbade both women and children to work underground. Bridon Ropes in Doncaster supplied the ropes that wound the cages up and down the mineshafts and it was women who did much of the rope making. Women took over much of the work in the railway construction and repair sheds.

International Harvester started producing agricultural implements in 1930, and the first tractor rolled off the production line in 13 September 1949.

Today, post-coal, steel and engineering work commerce and industry in (admittedly a less bucolic) Doncaster benefits enormously from its status as one of the UK's prime distribution hubs, due in large part to the town's excellent motorway and rail infrastructures. Doncaster International Railport sends prodigious amounts of goods to Europe by rail while there are large warehousing and logistic capabilities for retailers such as Next, Tesco, Ikea, Amazon and Faberge. The B&Q distribution centre next to the DFS UK headquarters at Redhouse A1(M) junction 38 was once the largest freestanding warehouse in the UK. Much of the fresh and frozen goods for northern supermarkets comes by road from Doncaster.

Doncaster Sheffield Airport opened in 2005. Tourism comes largely in the form of some fascinating specialist museums and in the races, not least the world-famous Doncaster Gold Cup and the St Leger.

This book also covers work and industry in the neighbouring towns of Conisbrough and Mexborough.

COACHING DAYS, RIVERS AND CANALS

As noted, transport and communications have always played a pivotal role in Doncaster's industrial heritage – be it canal, river, rail, road or air, or as an enabler and facilitator to the development of other local industry.

The town has from early times enjoyed superb road and water connections for both goods and people. Its very structure is determined by its role both as an entrepôt for the marketing of agricultural produce from the surrounding countryside and by its servicing of traffic up and down the Great North Road and along the River Don. Packhorse roads, then from 1740 turnpike roads, brought goods in from the west such as salt from Cheshire and textiles from Lancashire and West Yorkshire. Doncaster lies at the point where the Great North Road crosses the River Don, and was at the heart of turnpike roads linking it with Selby, Thorne, Worksop, Tinsley and Barnsley. There were additional links with places beyond along roads ever improving from the mid-eighteenth century onwards to give speedier and more comfortable passenger and commercial traffic through and around the area.

COACHING AND THE GREAT NORTH ROAD

Coaching services radiated out from London in the early seventeenth century, and the first service between London and York via Doncaster was established in 1655. The Great North Road ran through the centre of town. Mail coaches were introduced in the 1780s. We learn from White's Directory of 1837 the particulars of Doncaster's coaching services:

In 1837, 242 coaches left Doncaster throughout the year with a further 14 in summer. Of the 242 coaches, 42 went to London and 92 to Sheffield. In all, 98 coaches per week travelled to towns more than 50 miles from Doncaster. Furthermore, 91 of the coaches ran up and down the Great North Road, the rest plied cross-country turnpike roads. As well as coaches, 58 carriers' carts left Doncaster every week – two of them for London, but nearly all the rest for destinations less than 50 miles from Doncaster. There were 68 hotels, inns and taverns in the town in 1837, and eight of these were coaching inns with the Ram, Angel and Reindeer preeminent. Only two inns of the coaching era survive as fine examples of late Georgian architecture: the Salutation in South Parade, and the

Woolpack in Market Place. The council developers got the rest. Never were the words of T. P. Cooper more fitting when he described such wanton vandalism as 'The destroying hand of progress.' (T. P. Cooper, *The Old Inns and Inn Signs of York*, 1897)

The death knell for many a Doncaster pub, which were so often the victim of myopic and often plain ignorant council 'decision makers', even today.

In the seventeenth and eighteenth centuries the business generated by the stagecoach trade – through inns with stabling, pubs, markets, turnpike tolls, blacksmiths, farriers and shops – created the wealth that built the town centre.

Canal traffic created new and more extensive markets for Doncaster Coalfield coal. River ports were built at landlocked Bawtry on the Idle and at Doncaster on the Don to mitigate the absence of sea ports.

RIVERS AND CANALS

Improvements made to the River Don during the eighteenth century meant that by 1751 the river was navigable as far upstream as Tinsley, near Sheffield, an improvement which created the Don Navigation, part river and part canal. Coal, timber, grain, flour and metal goods constituted the main cargoes carried. The Don Navigation (Tinsley to Kirk Bramwith) was now a vital transport and trade artery linking the industrial west of South Yorkshire and the agricultural east. It also gave access to international trade via the River Humber and the port of Hull.

In 1837, for example, on average twenty-six vessels per week, including steam packet boats, sailed from Doncaster; eighteen to Sheffield; ten to Hull; two to Gainsborough; and two to London. When Hull and Goole developed their steamship capabilities it allowed increasing amounts of foreign and exotic foodstuffs to be sold at Doncaster markets. Some examples: apricots from Bordeaux, cherries from the Netherlands and France, lemons from Sicily, cranberries from Scandinavia and western Russia, oranges from Sicily, Portugal, Spain, Morocco, the Azores and Jamaica, and pineapples from the Azores. Sheardown exclaimed in *The Marts and Markets of Doncaster* (1872) that the effect of steam navigation enabled Doncaster market stallholders to sell oranges 'at a price almost less than apples can be grown in this country'.

Near the wharves, staithes, storage yards for coal and timber, maltings, tan yards, corn mills and warehouses was Hanley's flour mill, which opened in the 1840s. Hanley's ran a fleet of barges that plied up and down the Don Navigation and adjoining waterways until the mid-1960s. In the 1970s a scheme to resuscitate commercial traffic on the Don Navigation as far upstream as Sheffield came to nothing despite improvements made to locks to equip them with traffic light signals, as at Sprotbrough. Pleasure craft now use the Don Navigation, there is a marina at Strawberry Island in Wheatley, and narrowboats at Sprotbrough.

THE COALFIELDS

I n 1984, the Yorkshire coalfield could boast fifty-six collieries, thirteen of which were around Doncaster. The last deep coal mine was Kellingley Colliery near Selby, which closed on Friday 18 December 2015, marking the end of deep coal mining not just in Yorkshire but in the UK as a whole. Strict geographical definitions vary but, roughly speaking, in 1984, fifteen of the collieries were in the Wakefield district, nine in the Rotherham district, eight in the Barnsley district, thirteen in the Doncaster district, six in the Selby district, three in the Leeds district and two in the Kirklees district.

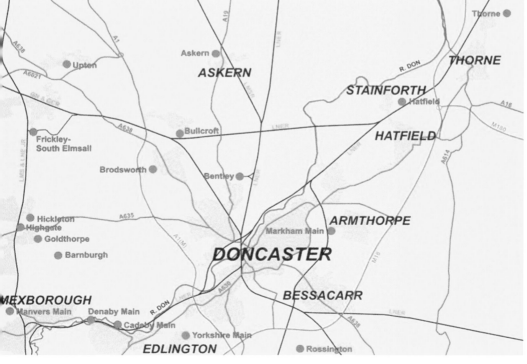

Map of Doncaster.

The post-nationalization collieries around Doncaster lie in the South Yorkshire Coalfield, which extends from Halifax in the north-west to the north of Bradford and Leeds in the north-east, Huddersfield and Sheffield in the west, and Doncaster in the east. Coal from the coalfield provided the bedrock for industry in the area: the coal mined here was a bituminous coal that was generally used for the production of coal gas and coke, which went on to be used for iron and steel manufacturing. Some seams with a low ash and sulphur content produced coal suitable for raising steam, while other seams produced coal for household use.

There is evidence of coal mining in the area in the thirteenth century and by the seventeenth century local coal and coke was an important industrial fuel in malting, glass making, smelting iron and for steam engines in trains and factories.

Initially, it was the shallower seams that were exploited, notably the Barnsley Seam; but when this became increasingly depleted, pit owners sank larger and deeper mines to exploit less accessible seams; for example at Manvers Main, Bentley and Brodsworth Main. The year 1929 saw these and other deeper pits come into full production and the South Yorkshire Coalfield produced record amounts of coal, peaking at 33.5 million tons, 13 per cent of the UK's coal output that year. Developments in pumping engines for drainage (Newcomen and Watt) and in winding gear and ventilation allowed ever-deeper shafts to be sunk and deeper seams to be mined.

The Doncaster pits, and their workers, were, of course, prey to the same threats and challenges faced by all deep mines throughout the twentieth century. Increasing competition from foreign markets and their prices led to some mines being amalgamated to reduce costs and improve competitiveness through the Coal Mines Act (1930). The market for coal was diminished first when ships moved increasingly to oil as their main source of fuel, and then when once coal-dependant trains were electrified.

The Coal Mines Act provided that all ventilating fans be reversible, enforced setting up of rescue stations, prohibited the use of furnace ventilators except where less than thirty employed underground or where seams were non-gaseous, and made mandatory the compulsory

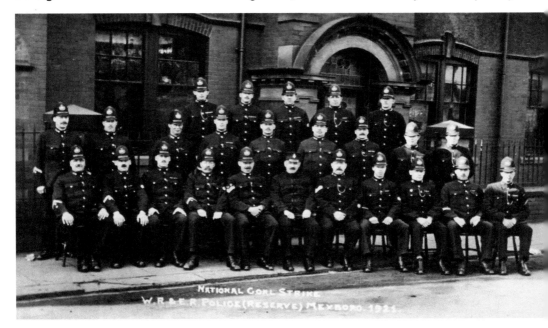

Reserve policemen at Mexborough, ready to police the 1921 national coal strike.

examination of boilers every fourteenth months. In 1924 there were still approximately 65,000 pit ponies working underground in British collieries; in 1925 pithead baths and canteens came into general use in British collieries; in 1930 the safety helmet was introduced; in 1938 the government nationalised the coal reserves; and in 1939 a diesel locomotive was working underground at Rossington colliery. By this date 61 per cent of coal output was machine cut.

The British coal-mining industry was nationalised in 1947, permitting the coalfield to be modernised; the National Coal Board closed inefficient and exhausted collieries, amalgamated other collieries to form larger working units allowing efficient machinery such as skip winders and coal washing and grading facilities to be used by several collieries and opened new drift mines that could be fitted with the latest technology. When nationalisation ended, these actions were carried out in a volatile and declining market. Then there was the ongoing toxic industrial relations and the miners' strike of 1984.

Coal sorting
at Bentley in
the 1920s.

The pit top
generator.

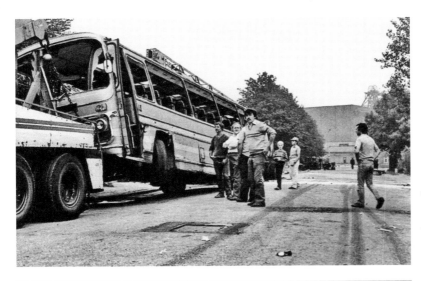

The miners' strike – they won't be catching this bus home.

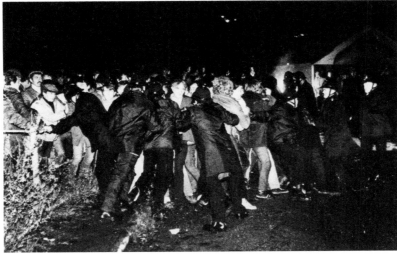

Miners' strike.

BENTLEY COLLIERY

Bentley Colliery, just a few miles north-west of Doncaster centre, is fairly typical of pits in the vicinity. It was opened by Nottinghamshire pit owners Barber, Walker & Co. and mining began in 1908. The initial workforce at Bentley were already in the employ of Barber, Walker & Co., who relocated from their pits at Watnall and High Park in Nottinghamshire. This, however, was not enough to fill the vacancies, so many others moved into the area from outside the region, building Bentley New Village to accommodate all the workers. The new village had a school, men's football team (Bentley Colliery FC), ladies football team and a cricket club.

By 1910 there were 1,000 employees, rising to an average of just under 3,000 between 1933 and 1947. The golden year for the mine was 1924 when over 1.3 million tons of coal was delivered to the surface.

Despite boasting one of the best ventilation systems in the mining industry at the time, the mine was plagued by problems with methane gas and by accidents and safety-related closures.

Disaster struck Bentley at 5:45 p.m. on 20 November 1931 when firedamp was ignited in the North East Colliery Face causing roof falls that prevented miners from reaching the shaft and the pithead. The initial explosion was followed by another inrush of gas, which robbed the air of oxygen. A crowd of over 2,000 people gathered at the pithead to wait anxiously for news. Four men went down into the pit wearing breathing apparatus and had to carry the injured over 2 miles to safety. For their bravery they were all awarded the Edward Medal with eight such awards being given in total. An inquest was opened and the Mines Department held their own inquiry, which lists forty-three dead, not the forty-five that is the accepted number. Five of the bodies could not be recovered.

Other Bentley disasters: in 1912, three men died and a further six were badly burned in an explosion underground; and in 1978, a paddy train conveying miners to and from the coal face derailed after it ran away on a downhill gradient and killed seven men with a further

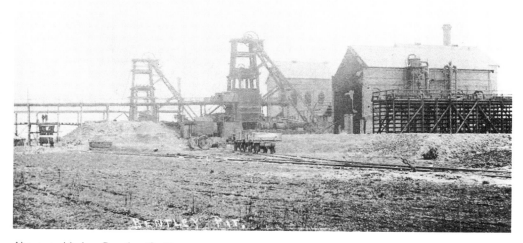

Above and below: Bentley Colliery.

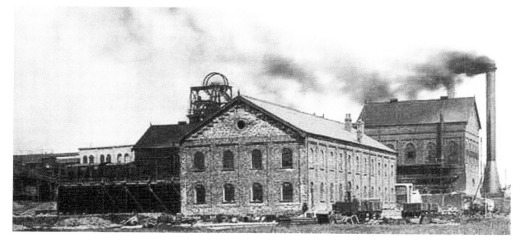

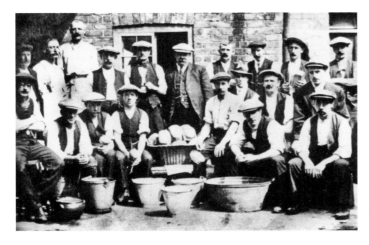

Bentley miners at their soup kitchen during the 1926 General Strike.

seventeen injured. A memorial service is conducted on the Sunday nearest to 20 November each year to commemorate those who died in the disasters.

Britain's first flameproof diesel locomotives were used for moving men and coal underground at Rossington and then Bentley collieries in 1939. Hand getting of coal had stopped by 1945 and the process was fully mechanised by the late 1960s.

The Bentley miners went out on strike during the 1984–85 miners' strike and again in 1988, causing seventeen other South Yorkshire pits and two in North Yorkshire to down tools.

In 1993 the mine was earmarked for closure by British Coal, despite a confidential report confirming that the colliery was operating at a profit and was producing coal much more cheaply than imports from, for example, South Africa. The mine closed in December 1993 with huge reserves abandoned underground and the loss of 450 jobs. Everything was demolished by 1995. In 1998 the site was handed over to the Land Trust. It was converted into a woodland in 2004 and is now open to the public as the Bentley Community Woodland.

I am indebted to the Northern Mine Research Society for much of the following detail https://www.nmrs.org.uk/mines-map/coal-mining-in-the-british-isles/yorkshire-coalfield/doncaster/.

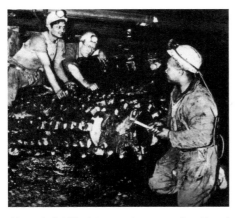 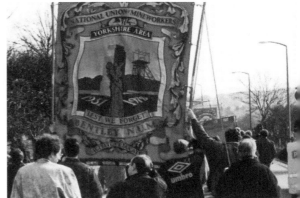

Above left: Working underground at Bentley in 1973.

Above right: Bentley miners on strike.

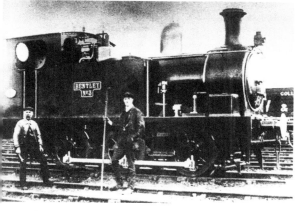

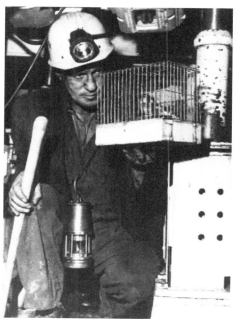

Above: Pit top engine, 1909.

Right: An interesting comment to the blogsite:
'The bloke with the canary is don brooks ...
who also worked with the dons (rugby league)
for summat like 50 years ... nice fella.'

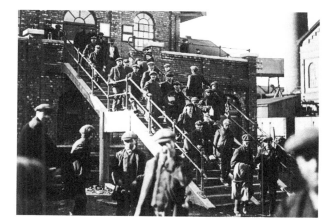

Clocking off in the 1930s.

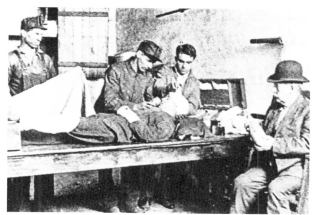

A casualty in the medical room in
the 1930s.

ASKERN MAIN (OPENED IN 1911, CLOSED IN 1991)

Askern was a pleasant spa village with its picturesque lake, the Hydropathic Establishment and the various bathhouses where genteel people came to take the waters. That is until the Askern Coal & Iron Co. Ltd began sinking two 6.55-metre diameter shafts here in April 1911. The miners came and the spa visitors stopped coming. Sir Samuel Instone eventually employed 3,000 men at the pit, most of whom lived in the purpose-built pit village of Instoneville.

Later, the Coalite Company came to town with its production plant. This was Doncaster Coalite Ltd providing high employment. The increasing pollution, however, soon became a local environmental problem despite its conformity to the Clean Air Act of 1956. The company's association with 245 trichlorophenol, a precursor of Agent Orange, which was a defoliant used in the Malayan Emergency and the Vietnam War, did nothing to allay local concerns. A fatal explosion in a pilot plant in 1968 in which a chemist was killed and dioxins were spread over the debris cannot have helped Coalite's worsening reputation. Problems continued with dioxin emission from the works incinerator, which burned residues from the chlorination plant near Bolsover, resulting in prosecution and a fine of £150,000 for contamination of the River Doe Lea (the river contained 1,000 times the safe level of dioxins in 1991) and surrounding farmland in 1996. In 1994, the river gained the dubious distinction of being the most polluted in the world with regard to dioxins. The pollution was believed to extend 13 miles downstream into the River Rother and the River Don, near Rotherham.

BARNBRUGH (OPENED IN 1911, CLOSED IN 1989)

Barnburgh Colliery was one of four pits that sent coal to Manvers Coal Prep. Plant – the other three were Manvers, Wath and Kilnhurst. These three sent coal underground while Barnburgh sent coal overland to the plant. The colliery suffered two disasters: on 24 April 1942 miners reported that the floor rose up towards the ceiling after downward pressure caused the floor to be forced upwards. Eighteen miners were trapped and despite frantic rescue efforts, four men died with the last two bodies removed some six days after the disaster. On 26 June 1957 an explosion caused by firedamp ignited by a 'flash' from a damaged cable resulted in the death of six miners and severe burning to fourteen others.

BRODSWORTH MAIN COLLIERY, WOODLANDS (OPENED IN 1905, CLOSED IN 1990)

Brodsworth Colliery would eventually grow to become the largest colliery in the country, employing 4,000 men who produced over 1 million tons of coal per year. The dynamic Sir Arthur Markham built a garden city called Woodlands to house the workforce. It comprised 653 houses along curving, wide and wooded avenues. The houses were in Arts & Craft style with Tudor gables. After his death, his sister Violet set-up an annual competition to be held in memory of her brother. The Arthur Markham Memorial Fund awarded a prize for the best essay written by a manual worker on a subject chosen for that year. The Markhams believed that there was untapped intelligence that needed to be rewarded.

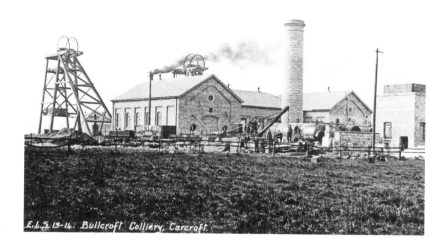

Brodsworth
Main Colliery.

When a third shaft was sunk between 1922 and 1923, the greatly increased coal-raising capacity raised the numbers employed underground from around 2,500 to 3,500 by 1925. The Coal Mines Act (1930) saw Brodsworth Main Colliery Co. Ltd become part of the Doncaster Amalgamated Collieries Ltd, which was worked until it was nationalised. Other pits in that scheme were Hickleton Main, Markham Main, Yorkshire Main, Bullcroft and Thurcroft. An underground link with Bullcroft Colliery was completed in 1970 and the latter's coal began to be raised at Brodsworth. The two mines were merged that same year and Bullcroft's workforce transferred to Brodsworth. In 1971 a rapid-loading bunker was added in order to accommodate Merry Go Round trains from local power stations.

BULLCROFT, CARCROFT (OPENED IN 1908, CLOSED IN 1970)

Once production started Bullcroft Colliery employed 3,000 men, most of whom lived in large housing estates in Carcroft and New Skellow built for the pit's workforce.

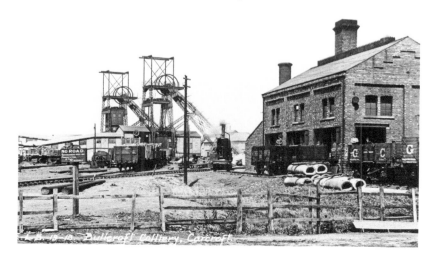

Bullcroft.

CADEBY (OPENED IN 1889, CLOSED IN 1986)

The Don is navigable to Conisbrough so the colliery had a staith for shipping coal to the Humber. Upstream, boats could use the Sheffield & South Yorkshire Navigation. Initially the colliery was only linked to the MS&LR's Barnsley to Barnetby line but this was soon followed by the South Yorkshire Junction Railway (later LNER Denaby Branch) and the LNER's Dearne Valley line.

The Cadeby Pit Disaster

At 1:30 a.m. on Tuesday 9 July 1912 a methane and coal dust explosion tore through Cadeby Main Colliery's South District, killing thirty-five of the thirty-seven miners working in that section of the pit. Hours later at the height of the rescue operation a second, more violent blast killed another fifty-three men. Three other miners died later, bringing the total death toll to ninety-one.

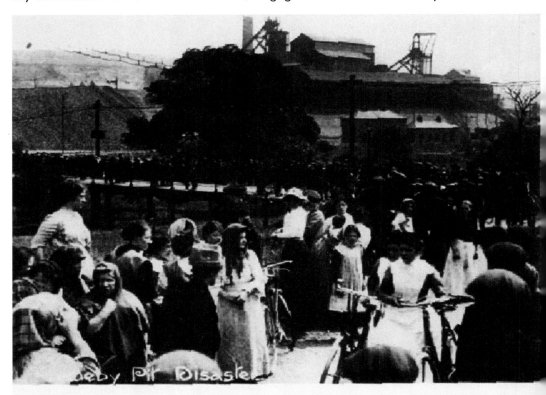

Cadeby Colliery Disaster
Between 2 and 4 o'clock on Tuesday morning 9th July 1912 there was a terrific explosion in the south district of Cadeby Colliery. Out of the 37 men who were working in that district, 35 lost their lives. The two men who survived the explosion were Albert Wildman and William Humphries. It was about 6 o'clock before the management could get to work on the recovery of the bodies. The Denaby and Cadeby Rescue Team were down the pit within half an hour, while within the same time span, the Wath Rescue Station had sent over a motorcar full of men. Accompanying the Wath team was Sergt-Instructor Winch and he marshalled the rescue operations. The Cadeby Colliery manager went down the mine whilst Harry Witty, agent of the Denaby and Cadeby Collieries, stayed above to superintend the many problems which required attention and to stem the rapidly rising confusion which threatened to overwhelm the officials. W. H. Chambers, the Managing Director of the company, was summoned from Newcastle; W. H. Pickering, Divisional Inspector of Mines, came from Doncaster with his assistant Gilbert Tickle; while from Sheffield came H. R. Hewitt and from Leeds H. M. Hudspeth and H. R. Wilson. At 9 o'clock the dead were carried slowly and reverently out of the pit mouth, down the long gantries in full view of the thousands of alarmed onlookers. From 7 o'clock until 9 the crowds had gradually accumulated in the roads leading to the pit yard.

The Cadeby Pit Disaster.

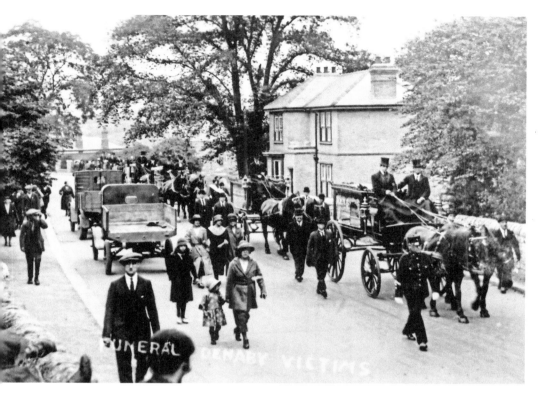

Cadeby Pit Disaster victims.

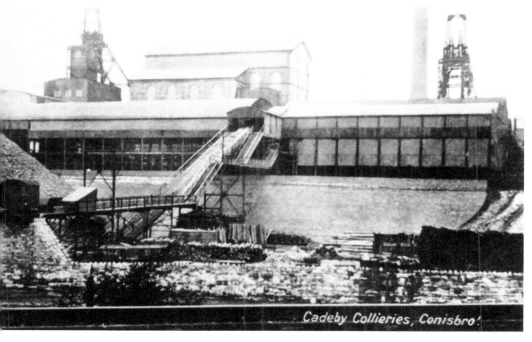

Cadeby Colliery.

However, the toll would have been much worse had it not been for the fact that the explosion occurred a day after the local community had turned out for a royal visit. On Monday 8 July, George V and Queen Mary had visited nearby Conisbrough Castle, an event attended by hundreds of miners from Denaby and Cadeby Main Collieries and their families. Many of the miners took an unofficial day's holiday for the royal visit, which meant only 117 reported for work on the Monday night shift. The previous week, 450 miners had clocked on.

DENABY (OPENED IN 1856 AND MERGED IN 1968)

In 1868 coke ovens were built at the pithead and the colliery was linked to the South Yorkshire Railway's Doncaster and Goole Railway (later the GCR's Barnsley to Barnetby line) and the South Yorkshire Junction Railway. As part of the NCB's rationalisation Denaby was joined by an underground link with Cadeby by 1956 and all coal then came to the surface at Cadeby. In 1967 the two collieries became 'Denaby-Cadeby' and the two mines were merged in 1968.

Denaby Main Colliery Company began building 2,100 houses to accommodate its workers and their families. Output targets were around 2 million tons of coal per year. A church, schools and a shop were also company owned. The company pub, the Denaby Main Hotel (better known as 'The Drum'), is one of the few properties from that era to have survived. Everything about the layout of the village said Industrial Revolution with parallel streets of

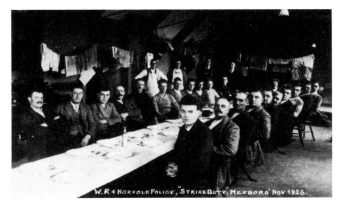

West Riding and Norfolk police at the ready for strike duty in 1926.

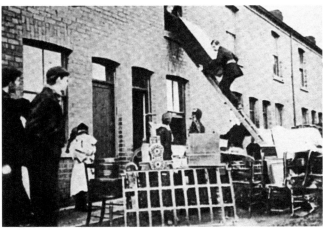

Police evicting miners.

terraced houses running off the Mexborough to Conisbrough road with the library and park at its centre. From almost every street you could see the colliery.

Not long after the mine opened, the village was dubbed 'The Worst Village in England' by an edition of the magazine *Christian Budget*. This is how those self-righteous Christian editors described it in 1899:

> ... so repulsive that many who have never been near it will probably refuse to credit the story...[where]... nearly all the men, and most of the women, devote their high wages to betting, where religion is forgotten, home life is shattered where immorality and intemperance are rife, where wives are sold like cattle, and children are neglected.

In actual fact, the complete opposite was much nearer the truth, with a community in which the miners displayed steely bravery in the face of ruthless employers – by the time the mine closed in 1968, 203 miners had lost their lives at work. Company policy allowed a dead miner's family to be evicted from the company-owned housing within weeks of bereavement.

In 1903 there was 'The Bag Muck Strike' caused by the mining company refusing to pay miners for the muck that they had to extract in order to access the coal. The mine owners started to evict strikers and their families, and many of those evicted had to spend January 1903 in tents on open ground with only sheets and blankets for warmth and soup kitchens for food.

This was not the first time the miners and their families were treated so atrociously. This is how the press reported it in 1885:

Denaby Colliery Evictions 6th May 1885

Yesterday the Constabulary ejected several topmen and their families from the colliery cottages at Denaby. No opposition was offered, the people behaving in a most orderly manner. Only officials and a few sick whom it would be dangerous to remove are now left in possession of the cottages. The evicted families took refuge in several tents which have been erected at Mexborough and Swinton. Yesterday a woman named Thompson who died several hours after being ejected was interred, the funeral being attended by about one thousand miners.

One of the Denaby & Cadeby boats.

In 1863 alternative employment arrived in the village in the shape of Kilner Brothers Glass, who opened a factory next to the mine (*see* Coningsbrough chapter). The first underground AC electric haulage engine was installed at Denaby in 1900.

Some colleries used their own shipping company to transport their coal. In 1912 the Denaby & Cadeby Main Collieries were given permission to anchor coal hulks offshore at Brixham, Devon, for twenty years. During 1912–13, 722 ships were refuelled with coal from these hulks and 667 in 1913–14.

One of the ships, named *Susquehanna*, was in 1921 sold to Denaby Shipping & Commercial Company, who changed their name to Denaby & Cadeby Main Collieries Ltd in 1924. She was converted into a coal hulk and kept in Brixham Harbour for coal storage. Sadly, in 1942 she was sunk in a German air raid in Brixham Harbour. Other vessels owned by Denaby and Cadeby Collieries were SS *Edlington*, sunk by German submarine UC-54 on 23 September 1918 to the south-east of Sicily with no casualties; the SS *Cadeby*, sunk on the 27 May 1915 20 miles south-west of Wolf Rock, Cornwall – she was captured by German submarine U-41 and scuttled; and SS *Normanton*, sold to the Rome Steam Shipping Company and sunk on the 1 October 1917 by U 39, again with no casualties. (The Conisbrough and Denaby Main Heritage Group has been a source of information for parts of this – http://www.conisbroughheritage.co.uk/index.html)

GOLDTHORPE (OPENED IN 1909, MERGED IN 1968)

In 1966 Goldthorpe was linked underground with Highgate and began winding all the latter's coal as a single mine, named 'Goldthorpe – Highgate', from 1967 to 1985.

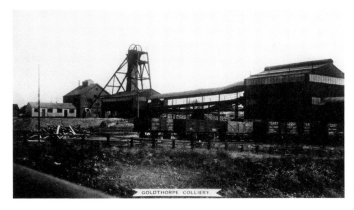

Goldthorpe Colliery in 1915.

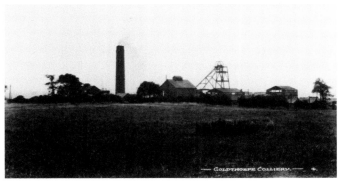

Goldthorpe Colliery.

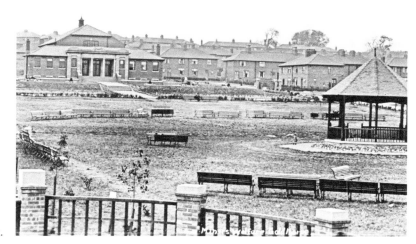

Goldthorpe miners' welfare, housing and park.

HATFIELD, STAINFORTH (OPENED IN 1911, CLOSED IN 2015)

Hatfield was constructed on a site next to the GCR's Barnsley to Barnetby line linked to staithes on the Sheffield and South Yorkshire Navigation by a mineral line. British Coal ended production on 3 December 1993 but a management buyout led to the incorporation of the Hatfield Coal Co. Ltd on 25 January 1994. The first year saw a profit of £2.4 million, but geological problems in 2000 cut the planned output by 20 per cent from 500,000 t/a. The company sought Operating Aid from the government, but this did not prevent the company going into receivership and closing the mine in 2001 with the loss of 223 jobs. With the doubling of coal prices between 2004 and 2008, Powerfuel was formed to adopt the colliery in 2006, and Russian coal company Kuzbassrazrezugol (KRU) took a 51 per cent stake in the venture. In December 2010, in part due to coal production problems, Powerfuel Mining Ltd went into administration. A worker-controlled company, Hatfield Colliery Partnership Limited (HCPL), purchased the mine from ING Bank in December 2013 while a £4 million bridging loan from the National Union of Mineworkers, in 2014, allowed production to be moved to a new pit face. This was intended to extend mining until summer 2016. Coal production at Hatfield ended on 29 June 2015, unable as it was to sell its coal due to increases in the UK carbon tax.

Just before Christmas 1939, disaster struck at Hatfield Main (as reported at http://www.minersadvice.co.uk/hatfieldmain.htm):

One man died and over fifty were injured when the cage carrying men to the surface crashed into the headgear. Doncaster Royal Infirmary treated 58 men and boys for their injuries, most suffering from fractured limbs, though ten men and boys were subjected to amputations of their legs.

A verdict of accidental death was returned at the inquest into the death of Daniel Horrigan, described as a stone worker of Arundel Street, Stainforth.

The jury at the inquest, held in The Guild Hall, French Gate, Doncaster, on Friday March 15, 1940, told the Coroner W. H. Carlile they were of the opinion that the safety devices did not cover a sufficient margin of error.

MANVERS, WATH-UPON-DEARNE (OPENED IN 1868, CLOSED IN 1988)

Manvers incorporated what was at one time the biggest coking plant in Western Europe. After nationalisation a plan was drawn up to combine Barnburgh, Kilnhurst, Manvers Main and Wath Main under which coal from Barnburgh was brought to Manvers on a surface railway, while that from the other three mines came to the surface at Manvers. This rationalisation saved on the cost of modernising winding plants, and ended the need for three coal washeries and other facilities. Barnburgh, Kilnhurst and Wath got new pithead baths and canteen facilities. In January 1986, with the merger of Kilnhurst, Manvers and Wath, the combined mine became known as the Manvers Complex.

When the Dearne Valley coalfields closed during the 1980s and 1990s, the government invested £68 million of public money into a regeneration programme to turn the Manvers area into a business park. Manvers Way Business Park has drawn £425 million from the private sector and produced 9,590 jobs in large and small companies. The site, originally managed by the local council, is now run by a private developer in Barnsley.

MARKHAM, ARMTHORPE (OPENED IN 1916, CLOSED IN 1996)

In June 1913 Earl Fitzwilliam leased the minerals under his Armthorpe estate to Sir Arthur Markham, hence the name. Coal first came to the surface on 5 May 1924. The site cost around £1 million and a model village for the pit, Armthorpe, was built.

For many years it was used as a training pit for the local area, with a training tunnel. In the 1950s it had around 2,700 workers. A domestic fuel processing plant was built in 1966. In the mid-1980s the pit had around 1,500 employees. At the end of the miners' strike in 1985, Markham Main was the last Yorkshire pit to return to work, three days later.

On its initial closure in 1992 it had around 730 workers. Under British Coal Corporation ownership Markham made losses and, despite its substantial reserves, was closed in 1992. In 1993 the pit was described as 'Non-operational', but it was reopened by Coal Investments Ltd in 1994. Heavy losses continued, however, and Markham finally closed in September 1996.

The brass band based in Armthorpe still performs – it is the last vestige of the pit. It was formed in 1924. The colliery has its own football team, which has competed in the FA Cup.

ROSSINGTON (OPENED IN 1912, CLOSED IN 2006)

The site chosen was 2.4 km west of Rossington, which was convenient for a link to the LNER line. It also accommodated miners' housing as New Rossington Model Village, which comprised some 1,700 houses by 1940. Conveyors were used in the Barnsley seam from 1933. Britain's first flameproof diesel locomotive was deployed underground at Rossington in 1939 for moving men and coal – Bentley soon got the same. From 1952 methane, extracted from strata near the faces, was piped from the mine and pumped 10 miles to Manvers Main, where it fired coke ovens.

THORNE, MOORENDS (OPENED IN 1909, CLOSED 2004)

The 12th of October 1909 was a fateful day in the history of mining: that was the day on which Pease & Partners Ltd, an ironmaking company with ironstone mines on the Cleveland Hills above Middlesbrough, began sinking shafts at Moorends, near Thorne. 'This was to become one of the longest and most difficult sinkings in the annals of mining. It was truly an ill-starred venture'. For the full story see https://www.nmrs.org.uk/mines-map/coal-mining-in-the-british-isles/yorkshire-coalfield/doncaster/thorne/, which concludes that 'In the end, Thorne had been fully productive for only 28 of its 95 years'.

UPTON (OPENED IN 1924, CLOSED IN 1964)

The Upton Colliery Co. Ltd was floated by Bolckow Vaughan & Co. Ltd of Middlesbrough and the Cortonwood Co. Ltd in 1923. Preliminary work, in preparation for shaft sinking, began in March 1924. Around 1939 the colliery was sold to Dorman, Long & Co. Ltd, who worked it until nationalisation. On 20 May 1964 an explosion occurred in the Barnsley seam, which was then sealed off, and Upton closed in November 1964 because it was 'no longer considered safe'. 136 men were retained for salvage and surface work.

WATH MAIN

The first of its two shafts were sunk in 1873, with workings reaching the Barnsley Seam three years later. To gain access to lower reserves the shafts were deepened, first in 1912 to reach the Parkgate seam and then, in 1923, to the Silkstone seam. That year there were 1,823 working underground and 546 on the surface. In 1933 output was 700,000 tons. As part of the National Coal Board, on nationalization in 1947 it was amalgamated, along with other local collieries, with the Manvers Main Colliery next door. It was closed on 25 March 1988.

On 24 February 1930 an explosion occurred at Wath Main when a safety lamp ignited firedamp, killing seven men.

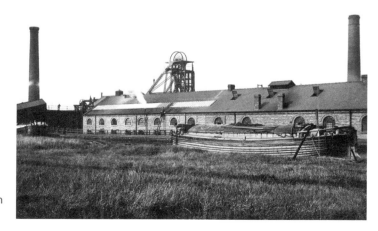

Wath Main Colliery, with a barge.

YORKSHIRE MAIN, EDLINGTON (OPENED IN 1908, CLOSED IN 1985)

In 1907 the Staveley Coal & Iron Co. Ltd, which owned a number of collieries in Derbyshire, acquired the mineral rights around Edlington. The site was served by the LMSR's Dearne Valley line and the LNER Gowdall & Braithwell line. A methane drainage scheme, opened in 1962, piped gas from the mine and, along with methane from Rossington, pumped it to Manvers coke works.

DONCASTER MINES RESCUE STATION

The only simulated 'underground' rescue training area near Doncaster was at Wheatley Hills Road. It was built in Arts and Crafts style in brick and stucco in 1913.

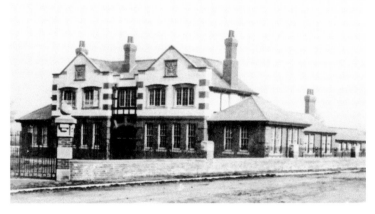

The Miners' Rescue Station.

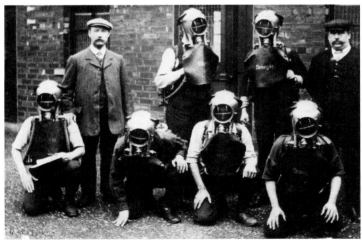

Rescue squad all kitted up.

DONCASTER IRON AND STEEL

Not only did locally mined coal forge a way of life and a viable means of living in the area around Doncaster, it also fuelled a number of other industries dependant on accessible coal for power. Steel was one of those industries.

South Yorkshire's steelmaking golden year was 1969 – according to the Iron and Steel Statistics Bureau (ISSB) – when it produced 3.6 million tons in a year. Now, output is just 1.3 million tons – though the Sheffield and Rotherham area accounts for 10 per cent of all UK steel production.

Doncaster has an undisputed place in the early history of steel production in the UK. Steelmaking using crucibles was invented and developed by Benjamin Huntsman in 1740 at the clock, lock and tool making works he established in the town in 1725. Huntsman was born in Epworth in Lincolnshire in 1704 to Quaker farming stock of German ancestry. He was also something of an experimental surgeon and oculist. All his medical work was dispensed free of charge.

His was the first to develop a way of producing steel of consistent high quality at scale. He heated small pieces of carbon steel in a closed fireclay crucible placed in a coke fire. The temperature he was able to achieve was 1,600 °C, high enough to permit melting steel for the first time, producing a homogeneous metal of uniform composition that he used to manufacture intricate watch and clock springs. However, in 1742 he moved from Doncaster to Handsworth, drawn by Sheffield's specialisation in steel and to be near the source of steel, fuel and clay. Here he set out to produce high-quality cast steel in his crucibles.

After years of trial and error in the outhouse next to his cottage he eventually, and secretly, perfected a method of making 'cast steel', which was 'refined' from the ends of bars of cementation steel in clay pots or 'crucibles' fired to a high temperature and each holding around 34 pounds of blistered steel. To these were added a flux, which was covered and heated by means of coke for around three hours. The molten steel was then poured into moulds and the crucibles reused. It persisted as the principle method of casting steel ingots until Bessemer invented his converter over a century later.

What drove Huntsman on was his frustration at the shortcomings and inconsistent quality of the existing materials for fine, detailed work, as in, for example, the making of clock and watch springs and pendulums and horological precision instruments. Huntsman continued with his alter ego work as a clockmaker, taking on an apprentice clockmaker in 1743. Huntsman managed to keep the wraps on his innovation for a decade or so, and it was only in 1751 that

he felt he could set himself up as a steelmaker and move to premises that he designed himself in Worksop Road, Attercliffe. A further move followed in 1780 to premises later to be known as 'Huntsman's Row'.

Local cutlers, however, did not buy his material, claiming that it was harder than the German steel they were accustomed to using. For many years Huntsman exported his whole output to France. The locals only relented when they observed, with some anxiety, the growing competition from imported French cutlery made, ironically, from Huntsman's cast steel. After failing to get the export of Huntsman's steel prohibited by the British government, the Sheffield cutlers were compelled to use Huntsman's steel if they were to survive. Had the lobby succeeded Sheffield would have lost its pre-eminence in tool making and cutlery— indeed its steel heritage — because Huntsman was considering overtures from more flexible manufacturers in Birmingham with an option to take his furnaces there.

A fortuitous coincidence of factors — Benjamin Huntsman's invention, the ready supply of local coal and iron ore, Sheffield's population tripling to over 400,000 between 1851 and 1901, the railways and finally the Bessemer furnace — all helped to drive growth still further. By the mid-nineteenth century, the Sheffield district made 90 per cent of British steel and nearly half the European output. Huntsman's high-quality steel gained world status for Sheffield, enabling Hallamshire to supplant London as the centre of excellence in cutlery production, and provided the catalyst for the rapid growth of an edge-tool industry for which Sheffield, via Doncaster, soon had an international reputation.

The London Chronicle, 14 July 1761, reported on 'the recent invention of Huntsman's crucible steel' and considered it ideal for sinking dies 'which produce excellent pieces'. 'Huntsman's patient efforts, at last rewarded with success, entitled him to an elevated niche among the heroes of industry; the invention of cast steel was second in importance to no previous event in the world's history unless it may have been the invention of printing' (an anonymous American, quoted by Sir Robert A. Hadfield).

Businesses, for example Ratcliffe's Ironworks, came and went in the latter half of the nineteenth century. Samuel Ratcliffe's Ironworks is a good example, which was established in 1867. Ratcliffe had worked as a superintendent of works at Brassey & Co. and had just returned from Italy to work on the Thorne Extension Railway. Sheardown (Doncaster, 1867) tells us that a perceptive Ratcliffe 'was struck with the advantage Doncaster possessed in its central railway position'. He bought 1 acre of ground in Hexthorpe to build his ironworks, and specialised in making 'iron girder-bridges, portable and stationary boilers, fire-proof roofs, gas-holders, water-tanks, brewing-pans; the manufacture and repair of coal wagons for private firms, with every description of wrought-iron work'. In 1867 this ironworks made a bridge for the Ludhill Colliery Company and two bridges for the West Cheshire Railway. In 1868 Ratcliffe supplied the iron pens and gates for the new cattle market. In 1869 a new foundry was built in the ironworks. He built a paper mill near the ironworks in 1869.

In Balby in 1909 there was Pegler Brothers, brassfounders, the Doncaster Wire Works. In the 1930s Doncaster Wire Works was acquired by British Ropes Ltd, and expanded. They built a huge new wire mill in 1938. New mining and engineering projects both in Yorkshire and the wider world gave a vital boost to this industry.

Sheffield, of course, was (and is still to a much lesser extent) the 'Steel City', but Doncaster can claim a cutting edge international manufacturer of steel ropes: Bridon International Ltd, part of Bridon-Bekaert The Ropes Group.

BRIDON INTERNATIONAL LTD

Bridon International are global market leaders in a number of key industrial sectors, including oil and gas, elevator, surface and underground mining, cranes and industrial, infrastructure, fishing, forestry, marine and cableways. They have eleven manufacturing locations and seventeen sales and distribution centres worldwide including four sites in the UK.

Headquarters are now at Balby Carr Bank, Doncaster. The company can trace its history in Doncaster back to 1789. Then the ropes were fibre but now they are of steel.

As steel forging became more advanced and common in rope applications Bridon emerged as a global market-leading spring, steel wire and wire rope manufacturer. Bridon have invested locally with the construction of the Bridon Technology Centre in Doncaster, whose goal is to develop new products and manufacturing techniques that will lead to the next generation of high carbon wires. Bridon is one of the founding members of the Institute of Spring Technology.

The name Bridon originates from the contraction of the words British and Doncaster. The company was formed in 1924 as state-owned British Ropes Ltd headquartered at Cavendish Square, London. From the 1960s to 1980s, British Ropes headquarters was at Warmsworth Hall at Warmsworth, west of Doncaster on the A1(M). Bridon and British Steel jointly owned

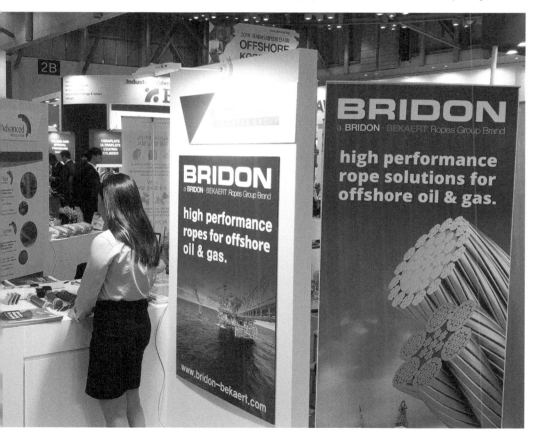

A Bridon stand at a trade exhibition.

the Templeborough Rolling Mills, which is now the Magna Science Adventure Centre. Forty percent of Templeborough's output went to Bridon.

Bridon Ropes supplied the ropes that wound the cages up and down many a mineshaft. Bridon made the steel ropes that support the arch at Wembley Stadium. They were also involved in the construction of the London 2012 Olympic Stadium.

MAGNA SCIENCE ADVENTURE CENTRE

The centre is a showcase for the rich steel heritage of the region. The highlight of this highly educational, very hands-on attraction is 'The Big Melt', the purpose of which is to demonstrate how steel was made in an electric arc furnace at Templeborough steelworks. The website tells us that 'An authentic looking furnace is imitated with several fog, spark, flame and smoke machines, loudspeakers, lights, and blasts of rapidly burning propane which are ignited at appropriate points in the show.'

The façade on the front of Manchester United's Old Trafford was manufactured by Doncaster business Norking Aluminium. Established around 1980 they also supplied the aluminium cladding for the Silverstone Wing at the world-famous racing circuit. The aluminium cladding and glass façade specialist Norking Aluminium was placed in administration in 2014.

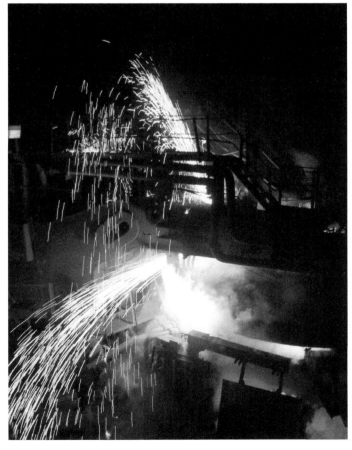

The furnace at Magna.

THE RAILWAYS

With the advent of the railways, the town enjoyed a renaissance as a major transport and communications hub. The railways transformed that modest coaching town on the Great North Road to a thriving industrial centre. The arterial Great Northern line reached Doncaster in 1848–49 with other lines radiating east and particularly west when the Great Northern Railway ran its Great Northern line through the town and established its Plant engineering works here. This in turn acted as a magnet to a myriad of ancillary industries serving the railway; together they transformed and developed the social and economic complexion of Doncaster. Passengers to York and points further north could continue their journeys via Knottingley and in the 1840s lines were built from Doncaster to Thorne and Goole, and to Rotherham to link with the existing Rotherham & Sheffield Railway of 1845. The year 1867 brought lines from Doncaster to Wakefield and on to Leeds, and to Gainsborough and on to Lincoln. The line to York via Selby between Doncaster and Selby opened in 1871, shaving miles off the existing York to London route through Knottingley. New lines such as the Hull & Beverley (fully opened in 1885), from Cudworth east of Barnsley to Hull, skirted the Doncaster area at Kirk Smeaton and Barnsdale, and the South Yorkshire Joint Railway in 1909 was built to compete for coal traffic and to serve the pits. Doncaster's need to transport coal speedily to Yorkshire steelworks only accelerated her growth through intense competition among railway companies. The South Yorkshire Junction Railway (opened in 1894) ran from Denaby, through Sprotbrough and Pickburn, to Wrangbrook Junction. The Hull & Barnsley built a branch in 1902 from Wath-on-Dearne to Wrangbrook Junction, and this passed east of Frickley. The Dearne Valley Railway, opened between 1902 and 1909, ran from Black Carr south of Doncaster to Edlington, Barnburgh, and eventually Brierley, from which its trains ran on other companies' lines to Wakefield. Its passenger service began in 1912.

Doncaster railway station was built in brick in 1849, replacing the timber structure. It was rebuilt in 1938 to house a booking hall, offices, subway and left luggage department, with modifications added over the years, most notably in 2006.

The South Yorkshire Joint Railway (opened in 1909) ran from Dinnington to Kirk Sandall Junction. The Great Central's 'Doncaster Avoiding Line' opened in 1910. A line from Braithwell to Gowdall on the River Aire was built jointly by the Hull & Barnsley and the Great Central Railways, and opened in 1916. It crossed the River Don by a steel bridge with curved girder top, which can still be seen just east of the A1(M) bridge across the Don.

The mercurial George Hudson, the 'Railway King', was behind a number of these lines, but Hudson did not have it all his own way. Arch-rival Edmund Denison MP (Sir Edmund Beckett), chairman of the Great Northern Railway, set up the London and York Railway to create a faster link from London to York via Doncaster. Hudson and the Midland Railway opposed the GNR, bizarrely submitting somewhat desperate, impractical plans to build an alternative route through Cambridgeshire and Lincolnshire. Common sense prevailed and the GNR abandoned their plans for a new line and settled for running right over the other two lines in order that their services could reach York. The earliest services between York and London ran via Doncaster, Retford, Lincoln and Boston, the line through Grantham and Peterborough only opening in 1852.

The Great Northern Railway Locomotive and Carriage Building Works was established at Doncaster. Repair works, the Plant, opened in 1851 and were expanded in 1865; steam engines were built from 1867 to 1957; and coaches were built from 1866 and wagons until 1869, chiefly at Carr Wagon Works. Miners and railway workers needed homes to live in, giving rise to an extensive housing programme. The chairman of the Great Northern, anxious about their workers' spiritual welfare, persuaded the directors to contribute towards the building of St. James' Church, which became known as the "Plant Church" and was funded by subscription by GNER shareholders. The railway also built St James' School.

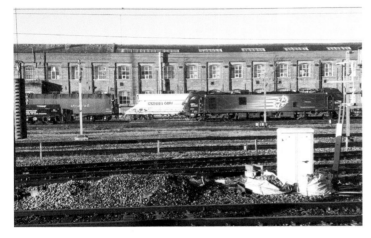

Outside Doncaster railway station in 2019.

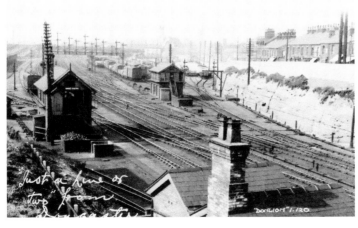

The Great Northern Railway Locomotive and Carriage Building Works.

THE PLANT

The Great Northern Railway Company's Plant Works was Doncaster's first large-scale factory. By the end of 1853, 949 workers were working here. By April 1855 it was working to capacity and new carriage shops were needed – repairs were being carried out in the open air. In the late 1870s a new wagon works was built at Hexthorpe to relieve the pressure; in the 1890s Doncaster's railway works extended for over 2 miles, covering 170 acres, housing ninety-six engines. At this time some 3,500 men were employed in the locomotive, carriage and wagon shops, working 1,100 different machines. During 1891 300 engines, 3,735 carriages and 15,226 wagons passed through these workshops, while 99 engines, 181 carriages, and 1,493 wagons were built as new stock or to replace old.

The Plant at Doncaster replaced earlier works at Boston and Peterborough. Its work was restricted to repairs and maintenance but that all changed when in 1866, Patrick Stirling was appointed as locomotive superintendent, and the first of his 875 class engines was built. At the same time, new coaches joined the production line, followed in 1873 with the first sleeping cars; dining cars and kitchen cars in 1879, the first to be built in the United Kingdom; and in 1882 the first corridor coaches were produced.

The list of celebrities coming out of the Plant is as impressive as it is prodigious. It included the Stirling Singles (fifty-three were built at Doncaster between 1870 and 1895 and designed especially for high-speed expresses between York and London.

Then there were the Ivatt Atlantics, whose purpose was to produce a powerful engine to haul the fastest and heaviest express trains on the Great Northern – the start of the East Coast 'Big Engine' policy – and the Gresley Pacifics, built at the Doncaster 'Plant' in 1922 to the design of Herbert Nigel Gresley, who had become chief mechanical engineer of the GNR in 1911. They included the *Flying Scotsman*, the first locomotive to achieve 100 mph and also run from London King's Cross to Edinburgh Waverley non-stop, and *Mallard*, which achieved the top speed of 126 mph on 3 July 1938 to become the world's fastest steam locomotive, a record that she still holds to this day. 4468 *Mallard* is a Class A4 4-6-2 Pacific steam locomotive built at Doncaster Works in 1938. She is now part of the National Collection at the National Railway Museum in York.

The last Ivatt engine in service was BR 62822, ex-GNR 294, which, on 26 November 1950, hauled a train from King's Cross to Doncaster to mark the end of the C1s. On board was

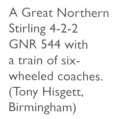

A Great Northern Stirling 4-2-2 GNR 544 with a train of six-wheeled coaches. (Tony Hisgett, Birmingham)

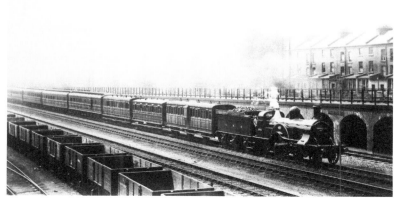

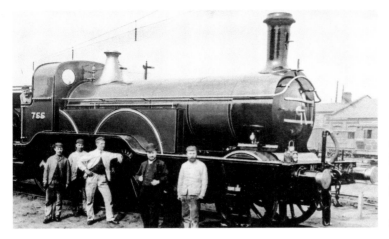

Great Northern
Railway 4-4-2 No. 755,
designed by H.A. Ivatt,
built at Doncaster in
1902 and withdrawn
around 1947.

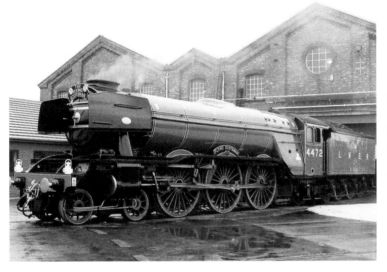

Photo of the *Flying
Scotsman* taken at the
Doncaster Works
at an open day in
2003, the 150th
anniversary of the
Plant works. The *Flying
Scotsman* was built in
Doncaster, so it had
'come home'. (Made
by Rich@rd)

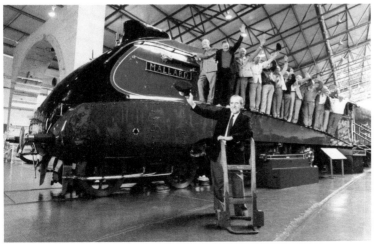

Mallard at the
National Railway
Museum in York on
the occasion of its
30th anniversary of
retirement in August
1993. Jim Fletcher is
shown with other
former drivers.
(Photo courtesy of ©
York Press)

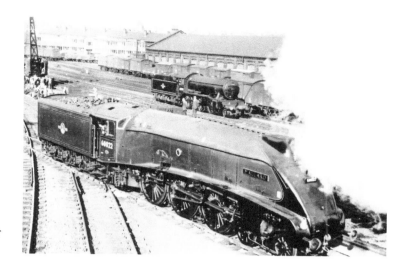

Mallard at Doncaster
in the 1950s.

the son of H. A. Ivatt. Pioneer 251, LNER 2800, has been saved for the national collection. Restored to GNR livery, she is the only C1 to survive and take part in the Plant centenarian event, celebrating the 100th anniversary of the Doncaster Works. In 1957 the locomotive arrived in York Railway Museum and is now at Shildon.

Galtee More entered service in 1924, was rebuilt (as here) in 1945 and withdrawn in 1962 to be cut up at Doncaster in 1963. Galtee More (1894–1917) was an Irish-bred, British-trained thoroughbred racehorse and sire. His racing career lasted from 1896 to 1897 when he ran thirteen times and won eleven races. As a three-year old in 1897 he became the seventh horse to win the English Triple Crown by winning the 2000 Guineas at Newmarket, the Derby at Epsom and the St Leger at Doncaster. At the end of the season he was sold to the Russian government and went on to have a successful stud career in Russia and Germany. He died following an accident in 1917.

During the Second World War, as with other rail workshops, the Plant contributed to the war effort, producing sections of Horsa gliders for the D-Day and Arnhem airborne operations. Tank hulls were also constructed here and plant was installed for the production and heat treatment of armour plate. Multi-barrel rocket projectors used in anti-aircraft defence were

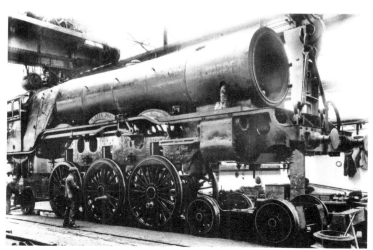

LNER 2548 (BR
60049) *Galtee More* in
the shed at Doncaster.

also manufactured. The carriage building shop was a victim of fire in 1940 but new buildings in 1949 were designed with the British Railways standard all-steel MK1 carriages in mind. Doncaster could also boast a well-equipped Works Training School for apprentice trainees.

In 1957, BR Standard Class 4 76114, the last of over 2,000 steam locomotives, rolled off the production line. Carriage building finished in 1962, but all was not lost as the works was modernised with the addition of a diesel locomotive repair shop. Under British Rail Engineering Ltd, new diesel shunters and 25 kV electric locomotives were built, as well as Class 56 and Class 58 diesel-electric locomotives.

Nevertheless, in 2007, Bombardier Transportation closed its part of the works and in the following year the main locomotive repair shop was demolished to make way for housing. Wabtec Rail is still occupied with passenger fleet refurbishment at Doncaster.

Fittingly, Doncaster is home to the new National High Speed Rail College, a specialist education and training institution dedicated to the future of the UK's railway industry.

The suburbs of Hexthorpe and Balby accommodated several industrial concerns directly connected with railways: the British Wagon Co. Ltd (wagon repairers), the Hexthorpe Railway Wagon Works (Thomas Burnett Ltd), the Lincoln Wagon & Engine Co. Ltd (railway wagon and engine repairers), Stevens' Wagon Works (Samuel Edward Stevens was another railway wagon builder and repairer); and Woodhouse & Co. Ltd (brassfounders).

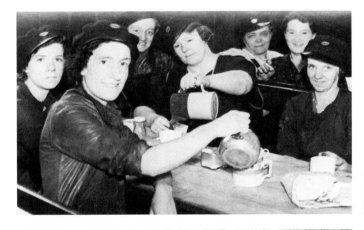

Night shift, 1942. Women LNER workers doing their bit and brewing up.

D9016 stands in Clapham Shed, after arriving from Alton, to collect the Queen of Scots stock to take to Doncaster for the Doncaster Works' 150th celebrations.

ACCIDENTS

Doncaster has witnessed three tragic rail accidents.

At 4:41 p.m. on 9 August 1947, the fourteen-coach 1:25 p.m. King's Cross to Leeds train crashed into the back of the twelve-coach 1:10 p.m. King's Cross to Leeds train between Balby Junction signal box and Bridge Junction, 0.75 miles south of Doncaster station (and in the same area as the rail crash of 1951). The back three coaches of the first train were almost completely destroyed by the (estimated) 40-mile-per-hour crash when hit by the 1:25 p.m. train. Seven hundred people were aboard the two trains. Casualties were eighteen dead and 188 injured, fifty-one of whom were taken to hospital.

The first train had been brought to a stand at a red signal near to Bridge Junction, and was just starting off again when the collision occurred. The second train was incorrectly signalled into the section, resulting in the collision. The signalman at Balby signal box (J. W. McKone) had accepted the second express into the section before clearing the first stationary train, even though it was within his sight of the box and was only 177 yards away.

The second tragedy was to occur four years later in 1951, just 400 yards north at Balby Bridge. On 16 March the 10:04 Doncaster to London King's Cross, consisting of 14 coaches and a horse box at the rear hauled by a LNER 60501 *Cock o' the North* left the station. Soon after the train was negotiating a tight crossover with a 10 mph speed limit, which the driver claimed he took at around 15 mph, but the third coach derailed. The front end of the coach followed the front of the train and went to the right of a pier supporting Balby Bridge, which carried a road junction over the line, but the rear of the coach, propelled by the weight of the following train, went to the left, wrapping the coach around the pier, killing fourteen passengers and seriously injuring twelve others.

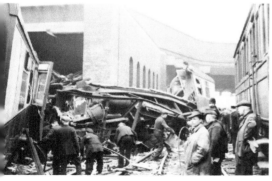
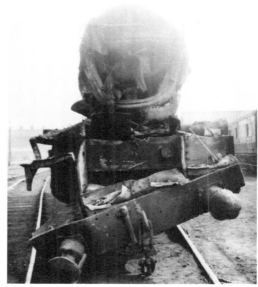

Above and right: Crash at Balby Bridge.

The Wath Road Junction accident occurred on 18 May 1948. The accident report tells us that the 11.45 a.m. down express passenger train from St. Pancras to Bradford, made up of twelve coaches and hauled by two engines, was travelling at 60 to 65 mph when the engines and eight coaches became derailed on a 30-foot embankment. The track had become distorted due to rail expansion caused by the sun's heat.

The express was only carrying 194 passengers since a crowded relief train had left St Pancras fifteen minutes earlier. Six passengers were killed, one passenger and one driver, B. Wilshire, later died of their injuries and thirty passengers and a dining car attendant were detained in hospital.

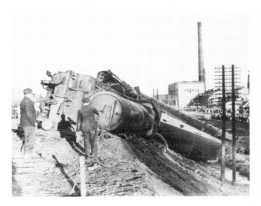 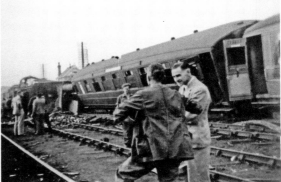

Above left and right: Wath Road Junction crash, 18 May 1948.

Below: Wreckage from a runaway train at Clayton West in October 1919.

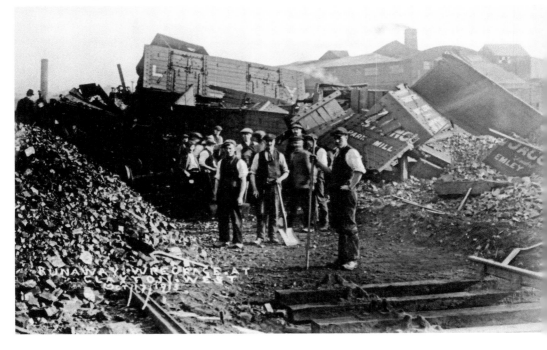

CONFECTIONERY

Yorkshire has a proud and famous heritage in the manufacture of confectionery. The root of Glycyrrhiza glabra – liquorice – is grown in abundance around Pontefract, which was the first place where liquorice mixed with sugar began to be used as a sweet just as it is today. It is often known as 'Spanish', supposedly because Spanish monks grew liquorice root at Rievaulx Abbey. Indeed, Pontefract is the centre of excellence in liquorice production. York is famously the home of Rowntree's, Terry's, Lazenby and Halifax's Mackintosh, but there is a lot more to Yorkshire confectionery than just York, Pontefract or Halifax. Needler's of Hull, Thornton's and Bassett's of Sheffield and Thorne's of Leeds have all been significant forces in the industry – the two Sheffield companies still are. Indeed, Whitaker's of Skipton, Dobson's of Elland, Riley of Halifax and Simpkin in Sheffield have nineteenth- or early twentieth-century origins and, along with Lion Confectionery in Cleckheaton, are still trading successfully today, the first three with retail outlets. Then there is land-locked and coast-free Dewsbury where Slade & Bullock perfected seaside rock. Finally, Doncaster is the home of Parkinson's butterscotch, Nuttall's mints and Radiance chocolates.

NUTTALL'S

Harry Nuttall established his confectionery business in Doncaster. His son William succeeded him and opened a new factory in 1909 in Holmes Market, employing 130 people. In 1912 Nuttall's Mintoes were launched, and they were so successful and popular that production of other sweets like the Liquorice Lump was suspended to satisfy demand. Later the company was taken over by Callard & Bowser, who continued to sell the sweets under the Nuttall's brand. Like others in the confectionery business (Rowntree and Cadbury, for example) William Nuttall was a noted philanthropist, donating large sums of money to help the people of Doncaster, and on his death in 1934 he left £221,000.

Finchley was the original home of Callard & Bowser, established in 1837 by Daniel Callard and his brother-in-law, J. Bowser. Their speciality was Creamline Toffee. They bought William Nuttall and were themselves bought by Terry's of York in 1982. The posters date from the 1890s.

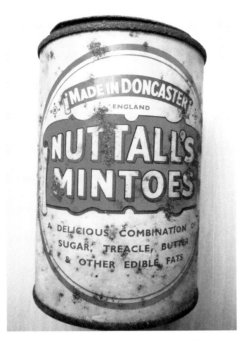 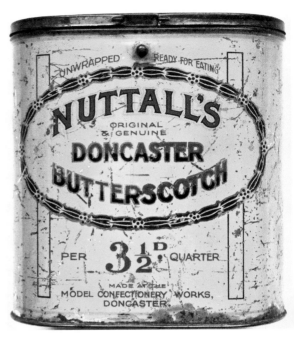

Above left and right: Confectionary from Doncaster.

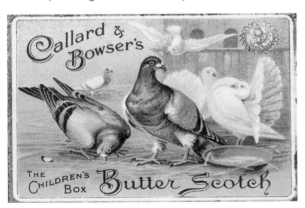

Callard & Browser's Butterscotch.

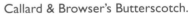

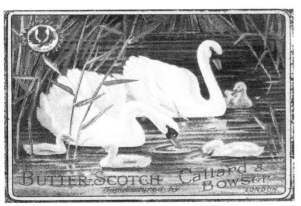

PARKINSON'S

Doncaster butterscotch is first recorded in 1848 and was sold by three rival Doncaster firms: S. Parkinson & Sons (possibly the inventors), Henry Hall and Booth's. Parkinson's in High Street started working life as a grocer and tea dealer, established by Samuel Parkinson in 1817. The firm also made baking powder. In 1905 they moved manufacturing to Station Road, then to a new shop in Printing Office Street. Finally the firm built a factory in Wheatley in 1912. The early High Street fine bow-windowed Georgian building also boasted a popular café. Since 1960 when Parkinson's left, it has been a coffee shop, bookshop and fashion store and was only saved from wanton demolition by the council through the efforts of Doncaster Civic Trust. It was restored in 1976 and is now a Grade II listed building. The shop may have closed in 1960 but the factory stayed open until 1977.

Their butterscotch was promoted as Royal Doncaster Butterscotch or The Queen's Sweetmeat, and reputedly was simply 'the best emollient for the chest in the winter season'. It was to become one of Doncaster's most famous exports and a highlight at the St Leger race week.

The Parkinson family connection ended in 1893 on the sale of the business to Samuel Balmforth and a sleeping partner. Incorporation as a limited company followed in 1912. In 1956 Parkinson's employed 600 or so people, mostly women. In 1961 the company was acquired by the Holland's Confectionery Group, which was itself taken over by the Cavenham Food Group in 1965. The business ceased production in 1977. The recipe was revived in 2003 when a Doncaster businessman and his wife discovered the recipe on an old folded piece of paper inside one of the famous St Leger butterscotch tins that was in their cellar. Parkinson's Doncaster Butterscotch Ltd, now defunct, was formed and produced and traded butterscotch worldwide using this original recipe. Today, the butterscotch is made and sold by Amy Smith's Traditional Confectionery, to the original recipe, from Bircotes.

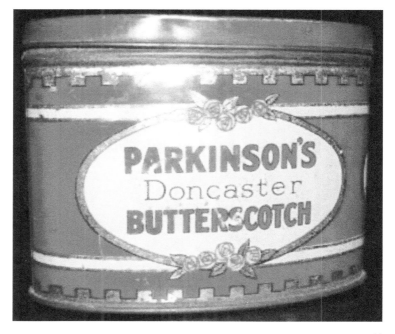

Parkinson's
Butterscotch.

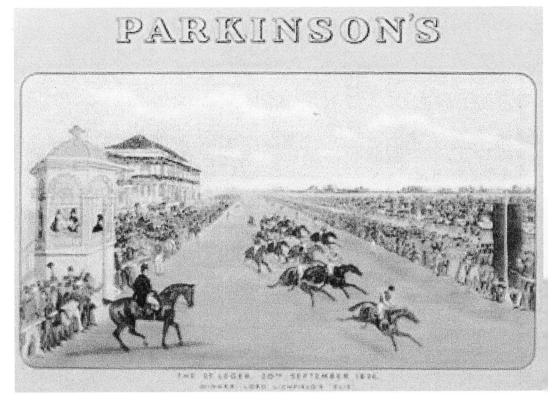

Parkinson's advert for St Ledger Races.

'Housewives Corner' in the *Liverpool Mercury* on Tuesday 1 February 1848 says that 'The real receipt for making Doncaster butterscotch, is one pound of butter, one pound of sugar, and a quarter of a pound of treacle, boiled together.'

Samuel Parkinson was also big in ladies' handgags and luggage. In 1841 Parkinson ordered a set of travelling cases and trunks from a London-based trunk maker H. J. Cave, and added to the order a travelling case for his wife's stuff. It had occurred to Parkinson that his wife's purse was too small and made from material too flimsy to withstand the journey. So, he told the luggage firm that he required a variety of handbags for his wife, varying in size for different occasions, and asked that they be made from the same hardy leather that was being used for his cases and trunks. Cave obliged and produced the first modern set of luxury handbags, as would be recognised today, including a clutch and a tote (named as 'ladies travelling case'). These can all be seen on display in the handbag museum in Amsterdam.

RADIANCE TOFFEE WORKS

Philys and Philip Jackson were the family that owned the Radiance Toffee Works, which was on Wheatley Hall Road. The firm had relocated from Scunthorpe. Lines included Devon Cream Toffee, Hazelnut Toffee, Extra Devon Cream, Creme-De-Menthe, Radiance Assortment, Riviera Assortment, Chocolate-Coated Toffees, and Brazil Toffee. They were closed in 1943.

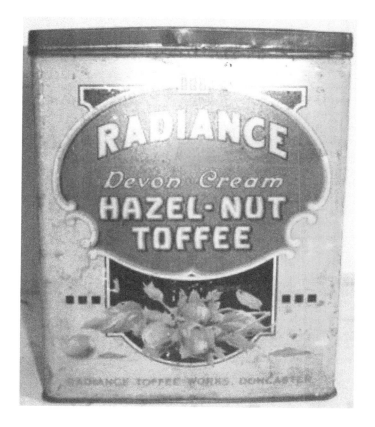

Right: Radiance Toffees.

Below: Radiance Toffees and some other Yorkshire confectionery.

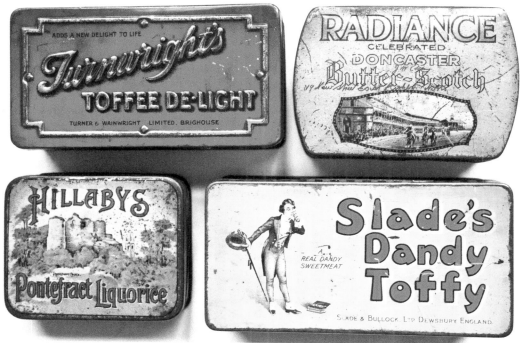

OTHER DONCASTER INDUSTRY AND BUSINESS

EARLY HISTORY

D oncaster has a history of textile manufacture, albeit not a very successful history. Defoe described Doncaster as 'a great manufacturing town, principally for knitting'. Knitted stockings were still being produced by the Clarkson family in Braithwell, 7 miles south-west of Doncaster, in the early nineteenth century.

In 1787 Revd Edmund Cartwright, inventor of the power loom, looked east and saw an opportunity to expand his cotton empire, so he built a cotton factory in Doncaster between Young Street and Wood Street. The Corporation officials must have been delighted. Cartwright installed twenty animal-powered looms, eight for calicoes, ten for muslins, one for cotton checks, and one for coarse linens. In 1789 the animals were replaced by a Birmingham steam engine. We know from Edward Miller that,

Each loom, which would do double the work of the best hand-weaver, was managed by a child; and was so constructed, that should the shuttle, which traversed at the incredible velocity of a hundred vibrations in a minute, meet with any obstruction, it instantly stopped without doing any damage to the work. E. Miller, *The History and Antiquities of Doncaster and its Vicinity* (Doncaster, 1804), pp.251

However, Doncaster was not Lancashire: power and raw materials were in short supply. Cartwright then tried to establish 'a factory for combing wool, spinning and weaving by machinery, and by the force of machinery' in Fishergate. This failed too and in 1794, the factory was converted to a corn mill, and later a flax mill. Another flax-spinning mill (and later sacking factory) was here, established by Matthew Johnson & Son, from 1818 to 1848. In 1868 a steam corn mill was built at West Laith Gate for Fawcett Brothers, which William Sheardown described as "extremely ornamental" in all its four-storey grandeur. That same year (1868) Marshall, Sons & Co. Ltd. of Gainsborough established their agricultural machinery depot in the empty National Schools in West Laith Gate. They 'converted the building into business premises, by altering the front and lowering the floor of the lower room', creating a showroom for their machinery including 'stationary and portable steam engines, grinding, threshing, and sawing machines ... other implement and machinery for agricultural and general purposes'.

Doncaster's railway industry attracted multiple other industries and businesses, making the town home to a cluster of ancillary industrial concerns. In addition, the local railway network had huge benefits for local industries in terms of distribution of finished products and the delivery of raw materials. In the mid-nineteenth century the area of Marshgate developed as an industrial area, with factories and housing for the workers. The year 1867 saw George Wilson open the Victoria Mustard Mills there, employing mainly young girls, and produced a whole range of food products, including table mustard, baking and egg powders, spices, custard powders, cattle food, ground rice, Epsom salts, carbonate of soda, tartaric acid, and 'drysaltery of all descriptions'. Victoria Mustard had export as well as home markets including Canada, Peking, Bombay, New York, and Germany. Also in 1867 John Elwes established his steam-powered saw mills in Marshgate, from which he built up an extensive trade in timber and sawn wood. The factory included stalls for nineteen horses, with a granary and workers' houses on an adjacent site. Mills for grinding corn and crushing bone, ironworks and brass foundries were also established.

THE TWENTIETH CENTURY

In Balby in 1909 there was Arnold & Son (builders and contractors) and two brickyards – Cocking & Sons and the Doncaster Brick Company. Cleckheaton-based Anderton's woollen spinning mill was built by 1912, whose owners were attracted to Doncaster by the town's pool of female labour, which prevailed until the 1960s. When the factory closed some of the women were bussed into Cleckheaton to work in the company's factory there.

From the 1930s to the 1970s many women worked in Burton's clothing factory on Wheatley Hall Industrial Estate, and from the 1960s to the late 1990s in SR Gent's clothing factory in St Sepulchre Gate. Wheatley Park Industrial Estate was served by a railway line linked to the main line. This attracted several important factories to the site including (British) Bemberg (later British Nylon Spinners, ICI, and DuPont), International Harvesters (tractors and other agricultural machinery), Crompton Parkinson's (electrical products), Burton's (clothing), and Binghams (electric welders).

Stephen Wade (1887–1956)
A Doncaster hangman on the Home Office List between 1940 and 1955, Stephen Wade first applied for a hanging post when he left the army in 1918, aged twenty-one. He was deemed to be too young but persisted and finally made it onto the list in 1940. After assisting both Tom and Albert Pierrepoint he finally got to be the No. 1 at the execution of Arthur Charles at Durham on the 26 of March 1946. He was usually selected by the Sheriff of Yorkshire for hangings at Armley Prison, Leeds, from 1947.

AGRICULTURAL MACHINERY

Case United Kingdom Ltd
Founded in 1842 by Jerome Increase Case as the J. I. Case Threshing Machine Company, it all began when as a young child, Case read about a machine that could cut wheat without people needing to use their hands. In the late nineteenth century, Case was one of America's largest builders of steam engines, producing self-propelled portable engines, traction engines

and steam tractors. In the twentieth century, Case was among the ten largest builders of farm tractors for many years.

Doncaster was one of fifteen Case manufacturing sites around the world, employing 1,000 out of 1,500 UK-based workers. In a year 17,000 tractors rolled out of Doncaster along with gear and shaft sets for 10,000 transmissions used in the Magnum tractor, which was assembled in Wisconsin. In 1984 Tenneco, Case's parent company bought selected assets of International Harvester.

International Harvester

In 1902 the McCormick Harvesting Machine Co. and the Deering Harvester Co. merged and formed International Harvester. Wardner, Bushnell and Glassner, Parlin and Orendorff and the Plano Harvester Co. also merged into this company. In 1903 a factory was built at Hamilton, Ontario, and in 1906 the first International Harvester tractor was produced at the Deering plant in Milwaukee.

In December 1906 a private company was established in the UK and International Harvester opened offices in Southwark Street, London, moving two years later to Finsbury Pavement. It was in 1938 that a UK division was established at Doncaster and in the second half of the twentieth century that International Harvester became known as the global market leader and cutting-edge manufacturers of agricultural machinery, especially tractors. The company was based at Wheatley Hall Road for more than fifty years.

During the Second World War the factory was used for the manufacture of bullets. In 1949 International Harvester's first tractor, Farmall M, was the first to roll off the production line. A year later the first British built diesel tractor was launched – the Farmall BMD model – followed by the B450, 885XL and Maxxum, giant industrial PAY-loaders, crawlers, balers and combines.

Tenneco acquired IH Farm Equipment Division in 1985. The International Harvester was acquired by the Argo group of Italy in 2000 and today trades as McCormick Tractors International Ltd. In 2007 the 435,836th tractor, an XTX215E, was the final product made in Doncaster before its doors closed, leaving the 371 remaining staff redundant.

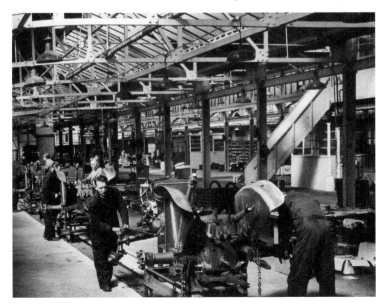

The assembly line in 1956.

AVIATION

Doncaster Corporation led the way at the very dawn of aviation in the United Kingdom when it embraced this new form of transportation. It was also host to the first English public aviation meeting, held on Doncaster Racecourse in September 1909. Aeroplanes from home and abroad included Bleriot and Farman biplanes. A replica of the Bleriot monoplane is on display at the South Yorkshire Aircraft Museum on the site of what was RAF Doncaster. RAF Doncaster first opened in 1908 as one of the world's first airports and later became a transportation squadron during the Second World War.

In the First World War, during the refurbishment of the Royal Flying Corps station at Doncaster in 1915, it was decided to move operations temporarily to an airstrip at Bancroft Farm at Finningley. The aircraft involved were probably Royal Aircraft Factory BE.2c fighters, whose pilots were mainly preoccupied with intercepting German Zeppelins. One of the large timber hangers survived until the late 1970s.

In the 1930s the Corporation drew up plans for a municipal airport on Low Pastures, allowing KLM to make Doncaster a stopping point on their Amsterdam to Manchester and Liverpool service, flying mainly Douglas DC-2s, one of which was named *Spirit of Doncaster* Nos. 7 and 102 RAF Squadrons moved in during 1936 from RAF Worthy Down with Handley Page Heyfords. The Second World War saw RAF Finningley opened with a role finishing crews with operational training for bombing. During 1940, Fairey Battles of 98 Squadron were posted to RAF Finningley from RAF Scampton. By August that year the critical situation led to 106 being placed on operational call, with most of its early sorties dropping mines in

Above: Avro Vulcan G-VLCN as XH558 on display at the Farnborough Airshow, 2008. (MilborneOne)

Right: First aviation meeting in England, held at Doncaster on 15–23 October 1909.

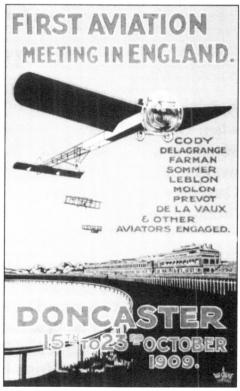

FIRST AVIATION MEETING IN ENGLAND.

CODY
DELAGRANGE
FARMAN
SOMMER
LEBLON
MOLON
PREVOT
DE LA VAUX
& OTHER
AVIATORS ENGAGED.

DONCASTER
15TH TO 23RD OCTOBER
1909.

the approaches to French Channel ports thought to be harbouring invasion barges. Bomber Command Instructors School was established at Finningley in December 1944. There were also airfields at Lindholme and Bircotes.

RAF Finningley played a pivotal role during the Cold War as a base for Britain's atomic bombers including Avro Vulcan bombers. The last flying Vulcan bomber in the world, Avro Vulcan XH558 (G-VLCN) *The Spirit of Great Britain*, is based at former air base RAF Finningley, now Britain's newest international airport, Doncaster Sheffield Airport (formerly Robin Hood Airport Doncaster Sheffield). The airport has one of the UK's longest runways thanks to the need to land Vulcans safely. It is so long that the airport is designated a space shuttle emergency landing site. XH558 remains in operating condition but without a permit to fly.

RAF Bawtry was No. 1 Group Bomber Command Headquarters in the Second World War.

CHEMICALS

Dupont

Formerly ICI, British Nylon Spinners and Bemberg, E. I. du Pont de Nemours & Company, commonly known as DuPont, is an American conglomerate that was founded in July 1802 in Wilmington, Delaware, as a gunpowder mill by French-American chemist and industrialist Éleuthère Irénée du Pont.

The Doncaster DuPont factory was built on land that was once part of Wheatley Hall. In September 1928, the *Leeds Mercury* announced a new artificial silk-making factory was to be established by German company J. P. Bemberg in Doncaster. By 1929, Bemberg had built a chemical plant, spinning rooms and general offices on nearly 80 acres of land.

In the beginning, skilled workers from Germany were brought over to train the British workers, the intention being that Bemberg be a British concern under British management, and employing British labour.

Before the factory opened during February 1931, twenty young men and men went the other way to Germany to undergo training in the production of artificial silk. The men were trained mainly for the spinning and partly for the preparation of the material, while the young women, whose ages ranged from seventeen to twenty, were destined for the textile department. On their return they formed the nucleus of the staff, acting as instructors to the other workers.

The thirty went to Wuppertal-Barmen in the Rhineland for six weeks, the centre of extensive manufacturing of ribbons, twine, thread, cotton and trimmings, with dye works and calico printing works. Raw materials for the works were imported from South America, landed at Hull and then transported by rail to Bemberg's own siding at Doncaster.

Initially, 412 men and twenty-three women, together with an office staff of around fifty, were employed. The factory had its own canteens, its own medical officer and good recreational facilities. By Christmas 1933, Bemberg was employing 1,000 staff, necessitating additional land to extend the factory. The plan was to supply from the Doncaster factory both the weaving and knitting trades of the UK, especially in Lancashire and Yorkshire. However, at the outbreak of the Second World War the German management were given thirty-six hours to leave or be interned. The factory then came under the aegis of Enemy Property and was then known as British Bemberg.

Ironically, the factory and its 200-foot chimney was a viable landmark for enemy aircraft and had to be camouflaged during the war, the camouflage remaining in place until the 1950s.

After the war the demand for rayon went into decline, largely owing to research in which chemists had constructed a polyamide based on adipic acid and hexamethylene diamine. The first fibre based on this new substance was known as nylon.

British Bemberg went into receivership in June 1953. A year later British Nylon Spinners (BNS) – owned 50/50 by ICI and Courtaulds – saw the potential of the Wheatley Hall site for nylon production.

Nylon spinning at the Wheatley Hall Road site started on 1 June 1955 on gravity units transferred from Pontypool in Wales. In 1957 a site expansion programme was announced. Production climbed steadily with Doncaster producing about half the company's output of yarn and staple fibre. In 1958 the number of employees rose from 1,100 to 1,700. In 1965 ICI took over Courtaulds' share of BNS and the following year set up ICI Fibres Ltd. Later in the decade, the workforce fell to 3,500.

ICI Fibres Ltd became Fibres Division of Imperial Chemical Industries on 1 January 1972. The 1980s saw a further reduction in staff from 1,513 to around 1,200. In July 1993 DuPont bought the ICI Fibres business. Employee numbers were further reduced from 850 in 1993 to 630 in 1995. (Much of this information is based on a brochure 'A Jewel in the Town' published in 1995 by Dupont).

GLASS

Glassmaking in South Yorkshire goes back some 250 plus years, and beyond that to the Romans.

Pilkington Glass Company

The Pilkington Glass Company was established in 1826 in St Helen's, Lancashire, under the original name of Greenall and Pilkington, dropping the Greenall in 1849. The Kirk Sandall site at Doncaster site was set up in 1922, benefitting from the canal nearby, which allowed coal and sand to be brought in efficiently. Houses were built on the land next to the factory for the workforce. In 1923 the company nurtured a partnership with Ford and together they 'developed a continuous flow process for the manufacture of glass plate and a method of continuous grinding'.

At its height during the early 1900s the Kirk Sandall site had over 3,000 employees, but by 1966 this number had been almost halved and the factory operated at a mere 56 per cent of its capacity. Despite modifications many of its practices and much of its technology were obsolescent. By 2008, the company decided that it was time to end production at the Kirk Sandall factory.

However, before that, Pilkington's performed an astonishing piece of PR: they built a glass pub in Kirk Sandall in and on which glass was used as a building material wherever possible. *The Magnet*, the John Smith (Tadcaster) brewery magazine for April 1968, takes up the story of the Glasshouse, originally known by the more prosaic Kirk Sandall Hotel up to 1956–57, and then the Glassmaker:

It was erected by Pilkington's, glass manufacturers, of St. Helens, Lancs., who have a large factory at Kirk Sandall, for their employees and to show off their "wares"… When it was first opened in 1934 it was regarded as being years ahead of its time… From the outside The Glassmaker appears as an oblong building with flat roof. One of its windows measures about 20 ft. x 10 ft and contains no less than 98 panes. Dogs, representing various breeds have been exquisitely cut into some of the panes. Inside the building the glass panels, squares and shapes of many sizes which surround the visitor on all sides are

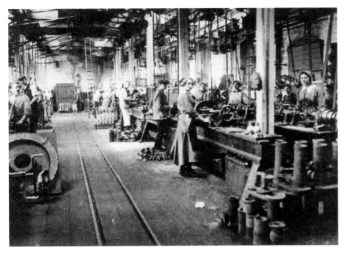

Pilkington munitionettes at work.

The Glasshouse before it was the Glasshouse.

One of the dog-themed windows.

Built of glass
but you can't see through it

The Glasshouse as the Glassmaker. (*The Magnet*, April 1968)

of many colours. Those used in what is known as the Gold Room are very rare and are known as "rough cast printed and fired gold"… The door of this room is of armour-cast toughened glass… The mirrored walls of one quite small room turn it magically into a vast auditorium and three or four people are multiplied into hundreds.

Rockware Glass of Greenford had a factory at Doncaster on Barnby Dun Road as well as those at Worksop, Knottingley and Irvine, Scotland. Rockware became part of Ardagh Glass Group in 2006. The Doncaster plant opened in 1934, employing 800 people. In 1969 they opened a new factory at Wheatley, Doncaster, with five furnaces.

CRIMPSALL INGS POWER STATION

Doncaster's power struggles began in 1898 when the good people of the town got fed up with being left in the dark. So some of the town's leading tradesmen lobbied the Board of Trade to provide a public supply of electricity for the growing town.

A power station was duly built in 1900 in Greyfriars Road near the canal for the convenience of coal-carrying barges and a ready water supply for cooling. The Mansion House, Regent Square and Spring Gardens were the first to benefit but the tramway system, which first took its supply in 1902, was the biggest single user out of the 143 customers.

In 1933 Doncaster was finally connected to the National Grid and a second, bigger power station was built. Doncaster Power Station was a coal-fired power station located on Crimpsall Island, surrounded by the River Don and the Sheffield and South Yorkshire Navigation. It opened in 1953 and received its coal by boat, at its own staithe. It closed on 31 October 1983.

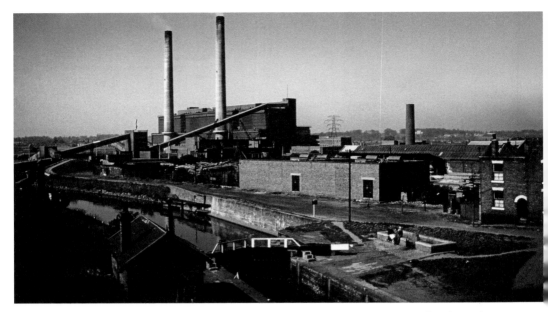

Doncaster power station in 1957, taken from St Mary's Bridge, looking west. On the right just visible behind the right-hand chimney is Cusworth Hall. (Photo taken by the late Leonard McKone)

MALTINGS AND BREWERIES

South Yorkshire is an ideal 'malting county': a county of industry and agriculture. The former meant a need for drink, in the form of beer, and the latter supplied part of that need in the form of good-quality malting barley from the malting industry of the industrial West Riding; this local produce was supplemented by foreign barley, imported via Hull. Maltings were sited along the canals, and later along railway lines of Yorkshire.

As with many industrial cities, Doncaster was once home to a number of malt houses and breweries. The Industrial Revolution provided the impetus for the growth of commercial breweries with new technologies and economies of scale, and also created a mass market for beer by bringing large numbers of men and women together in factories, mines, forges and furnaces, who quaffed quantities of beer as an important social activity, a safe source of drinking water, as energy, and as a means of rehydration. As industry and cities grew, so did the number of commercial breweries and pubs that served them.

Darley's Brewery
I am grateful to 'The Darley Family and Thorne Brewery' by Malcolm Hobson, Thorne and District Local History Association Occasional paper No. 17, 1994, on which the following information is based.

The Darley family have been brewing beer at the King Street Brewery, Thorne, continuously for over 150 years, and before that the Whitfield family ran a small brewery on the site. William Marsdin Darley was born in 1827, and was the founder of the Darley brewing business. His

father, Charles, married Susannah Marsdin, daughter of a Stainforth farmer, and records have him down as a 'shipowner, landowner' and 'bone merchant'.

Another record shows a bill that hung in the sampling room of the brewery and stated that a certain Mr Acaster bought 9 gallons from Mr Darley in 1850 – probably Darley's first sale.

By 1863 the balance sheet records, 'Household property and land £12,398 17s 8d. Fixtures, horses and plant £ 1,406 4s.' Turnover for that year was just under £21,000. Other items of interest from the 1863 balance sheet include a list of the types of beer produced in 18 gallon casks. There were three strengths of mild ale at 15s, 18s and 21s per cask. The middle strength ale seems to be the most popular. Also produced were bitter beer, strong porter and ordinary porter with a small amount of old ale.

Stock of spiritous drinks in the cellar were valued per gallon: gin at 10s and 5d, brandy at 22s, Jamaica rum at 12s, Scotch whisky at 15s and 6d. Tradesman hired in the upkeep of the brewery included J. Wilkinson (plasterer), R. Coggan (saddler), J. Kay (blacksmith), J. Chester (painter), J. Tomlinson (cooper), J. Darley (bricklayer), and W. Rollit (iron founder). The billiard table and furniture in the Billiard Room of the 'White Hart' was valued at £100.

In 1876 a new bottling plant was bought and installed for £86 15s 11d, and the horses and carts were valued as follows:

Waggon £35,00
Two Spring Carts £30,00
Coal Cart 60s
Coal Cart (Bought at Doncaster Show) £11.00.
Hand Cart £2.00
Harness £10.0.0
Grey Mare 'Rose' £30.00
Chestnut Horse 'Boxer' £10.00
Bay Mare 'Brandy' £15.00
Black Horse 'Farmer' £30.00

In 1902 William Darley's son, C. W. Darley, rebuilt the brewery on King Street, with its brick tower and chimney. C. F. Darley, son of the above, was born in 1880. He and his father worked very closely with the maltsters who supplied the brewery, Milnthorp's, the malting house near Barnby Dun station. Work on a new malthouse at Barnby Dun, Barnby Dun Maltings, was begun, and a contract signed to guarantee 5,000 quarters of barley to be carried by the South Yorkshire Navigation Company each year for the next five years.

Bert Jarvill was a Darley's Brewery drayman before the First World War, when he was blinded. He had a pair of horses, each weighing nearly a ton, to pull his wagon of ale to the various inns within a radius of 12 miles or so of the town.

Darley's beers were shipped on a steam flyboat called the *Swift*, which (up until 1994 at least) could still be seen as a houseboat in Stainforth basin.

'Every Monday at 6 a.m., Darley's horse-drawn wagons took hogsheads of beer to the canal's free wharf near the present Thorne Engineers' workshop opposite the Canal Tavern. Forty-five tons of casks were loaded on to the *Swift* in three hours and then taken to Hull. By 11 a.m., on Tuesday morning, the beer had been off-loaded under the supervision of Mr Hayes and taken to Darley's agents' premises at Leonard Street, near Queen's Docks, for further distribution'.

In October 1978 Darley's was sold to Vaux Breweries of Sunderland, with Darley's continuing more or less independently. In May 1986, Vaux announced that Darley's Brewery would be closed that September.

Barnby Dun Maltings
In 1871 the population of Barnby Dun was 484: one part-time malster, four butchers, three corn millers, two boat owners, one saddler, one coal merchant, four publicans, four boot and shoe makers, one farmer/malster, thirteen farmers, six shopkeepers, three tailors and three wheelwrights.

George Frederick Milnthorp was a prosperous landowner and farmer who brought prosperity to the village when in 1860 he built his first malt kiln, which was three storeys with twenty-three bays, in association with Darley's Brewery. By 1907 he had built two more in the village, enabling farm labourers to work all spring and summer in the fields and then in the kilns in winter. In 1920 he sold land to Pilkington's so that they could build the village of Kirk Sandall for their glassworkers. In 1964 his nephew sold out to Tetley Brewery.

Alfred M. Eadon & Co. Ltd, Plant Brewery, Sunny Bar
Originally owned by the May brothers, this brewery was established in June 1894 in this distinctive building on the corner of Sunny Bar and Market Street. It was acquired by Warwicks & Richardsons Ltd of Newark-on-Trent in 1897 with sixteen public houses, which itself was bought by John Smith's Tadcaster Brewery Co. Ltd in 1962. Brewing ceased in 1966.

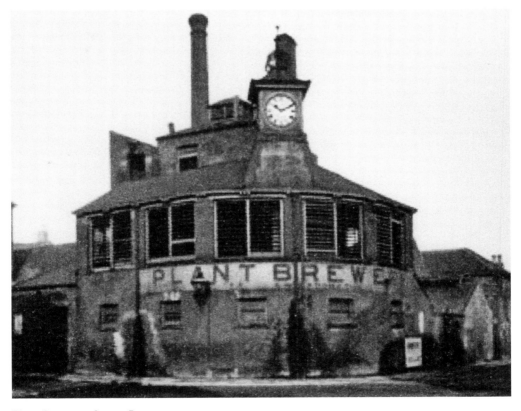

Plant Brewery, Sunny Bar.

Some of their pubs are listed below:
Camden Arms, St James' Street, Doncaster (acquired in 1880)
Cheshire Cheese, Wheatley Lane, Doncaster (acquired in 1887)
Sun Inn, York Road, Doncaster
Beecher's Brook, Ascot Avenue, Cantley, near Doncaster
White Hart, Swan Street, Bawtry

Other Breweries
The Crown Brewery in Doncaster's Fitzwilliam Street was taken over by Thomas Windle of the Old Exchange Brewery of Cleveland Street in 1896. He closed it two years later. The Old Brewery in Market Place traded as Taylor & Co. until 1870 when it was sold to Elizabeth Levitt and then to the May Brothers of Plant Brewery fame. The Mays continued for twenty years before selling it to the Dickinsons, who closed it in 1894. The site gave way to a covered cloth market. Jonathan Cooke owned what became Alfred Ream & Son in 1860 in Cleveland Street and then William Wrightson Harrison by 1872. Alfred Ream took control in the mid-1880s until the firm was sold to John Smith's. The Old Exchange Brewery, or Windle's, was bought by Thomas Windle from Joseph Erskine Bainbridge in 1889 and then sold to Whitworth, Son & Nephew of Wath-on-Dearne, who kept the beer coming until 1915.

There was home brewing activity in the following Doncaster brewhouses:
Scarborough Arms, Cleveland Street, with Thomas Martin as brewer in 1860
Little Red Lion, Market Place
Old Volunteer Inn, Frenchgate, by William Sayles in 1909
Mason's Arms, Market Place, by William Vaux in 1900
The Don Valley Brewery Company, formerly Winder & Co. was in Hatfield near Thorne. It closed in the 1930s.

There were two breweries operating in Wath-on-Dearne: Holme's Winterwell Brewery and Whitworth, Son & Nephew on Moor Road. Spedding Whitworth took over what was James Utley & Co. in the 1889s, operating from 1891. They then acquired the Mexborough Brewery in Bolsover, Windles of Doncaster in 1896, Marians of Sheffield in 1903 and Nicholson Brothers of Conisbrough (1860) in 1902 and closed in 1909. Whitworth was itself taken over by John Smith in 1958 with their 165 houses. The malting can be seen at the rear of Cadman Road.

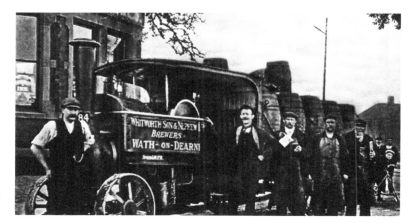

Whitworth, Son & Nephew Brewery.

Conisbrough was also home to Ogley's Home Farm Brewery. Founded in the 1860s, it supplied the Hill Top Inn, the Eagle & Child in Conisbrough and the Ferry Boat Inn in Mexborough (the latter two later Mappin's of Rotherham houses).

Some Doncaster Pubs

Recent years have seen an explosion in the number of microbreweries turning out some quality craft beers. Here are some which have started up in the Doncaster region:

Concertina, Mexborough, 1992
Cooper & Griffin, Bawtry, 2014
Glentworth, Doncaster, 1996
Hilltop, Conisbrough, 2014
Imperial Club & Brewery, Mexborough, 2010
Doncaster, Doncaster, 2012
Don Valley, Mexborough, 2016
Stocks Brewing Co., Doncaster, 2018
1086, Cusworth Hall, 2018

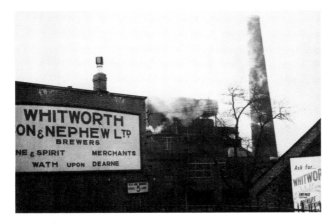

Left: Whitworth brewery in 1955.

Below: Punch's Hotel, Bessacarr.

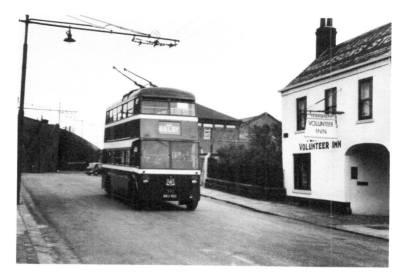

The Volunteer, Balby.

Doncaster Brewery beers. (Courtesy of Doncaster Brewery)

MOTOR VEHICLES

Cheswold

Doncaster had an important role in the very early days of the motor car manufacturing industry. E. W. Jackson & Son turned out the prestigious Cheswold car at their Frenchgate Works before the First World War with between 75 and 150 cars coming off the production line between 1910 and 1913. The name came, as with the Cheswold Works where it was made, from the River Cheswold now culverted below the streets. This firm was founded in 1904, just before their manufacture of cars began, and in 1913 the company was one of the first distributors for Morris cars. An Austin main dealership followed in 1919 with sales too of MG, Riley, and Wolsley. In the mid-1970s the firm was absorbed by Rocar while the garage and showroom on Churchway and in Frenchgate both closed in 1981.

The Chesworld was a 15.9-horsepower car with a four-cylinder engine. At least five models were designed for the top end of the market: a limousine, a convertible tourer, a coupé, a drop head coupé, and the ambulance. The first motor ambulance in the Doncaster area was this

Cheswold, made for the Askern Coal and Iron Company. They continued in service until the Second World War. Extant photographs show that the Cheswold ambulance was also supplied to Cadeby Main Colliery Company.

Why did production come to an end? At the start of the First World War Jacksons switched to aeronautical and mechanical engineering work for the war effort. Peace brought the insatiable demand for mass car production, something which Jacksons were not equipped to manage.

In 2011 this fascinating post (by Barrie) appeared on the Old Classic Car Forum (www.oldclassiccar.co.uk/forum/phpbb/phpBB2/viewtopic.php?p=71320&sid=19156732132d46b689b17e9dafc4c803):

I have discovered that in 1912 when my wife's great-great-grandad Frederick Theaker bought the car they were being sold £450. I haven't done the inflation maths from then till now but i'm sure it was a significant amount of money nearly a hundred years ago! The Cheswold was the first car in Hemsworth where he lived, and we still do, and he couldn't drive. He sent John Willie Nobes, one his farm employees, to the E. W. Jackson and Son factory to be taught to drive. When the car broke down they pulled it back to the factory in Doncaster by horse for repair.

A Cheswold in Doncaster Museum.

Jacksons Ladies FC, 1921. If you compare this picture with the next one you will notice that they were taken on the same occasion: two members of the Bentley team can be seen peeping through the window and the two non-players are in both pictures.

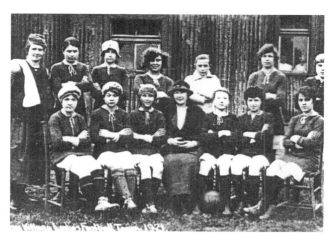

Bentley Ladies FC, 1921. It was later named Doncaster-Bentley. Seated from the left: Lucy Bromage, Gladys Bromage, Maggie Murphy, goalkeeper (in white) and Ivy Moulton. (Photograph courtesy of Gilbert Bromage)

R. E. Arnett Ltd

R. E. Arnett Ltd started out in 1946 when the Arnett brothers, Eddie and Robert, bought the assets of the automotive part of Bernard Cutriss Ltd in which they had both worked since the 1920s. This company was a conventional garage in those days but their expertise widened to a specialisation in repairing and maintaining vintage engines. The company still trades in Kelham Street.

Brook Crompton

Brook Compton, electrical engineers, has its origins as Crompton & Co. in Chelmsford around 1878 when the lights first came on to illuminate our streets. Electrical systems were their forte, including electric motors, cooking and heating appliances and traction equipment. In 1927 they merged with Yorkshire firm F. & A. E. Parkinson to form Crompton Parkinson which had thriving domestic and export markets.

The company moved to Doncaster in 1940 to make small arms munitions. Brook Crompton trades today from their HQ in Huddersfield as a leading provider of energy-efficient electric motors.

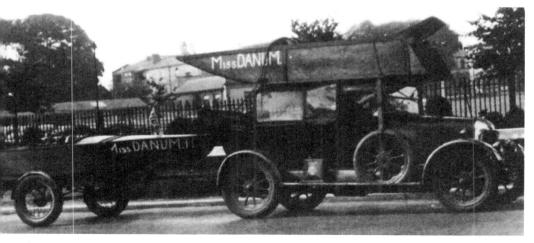

A vintage Bullnose Cowley serviced by Arnett's around 1930.

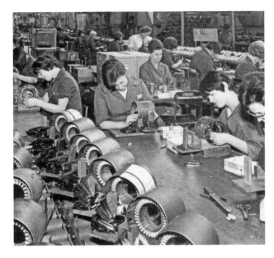

Hand insertion of coils before machines did it.

RETAIL

Doncaster, as with any other towns and cities, had a good range of shops – some chains, others independent. Here are some of the more interesting ones.

Meller's Dolls Hospital

If dolly was poorly then there was only one place to go: Dr Ted Meller at the Dolls Hospital. Charles Edward (Ted) Meller's Market Place shop was demolished around 1926 for the Scot Lane widening scheme, necessitating a move to No. 55 Hall Gate. Ted Meller did his surgical training on a large consignment of damaged and limbless dollies on which he performed a series of limb transplants to make them better, and whole, again.

By 1945 the shop was the largest of its kind outside London. The first delivery van was a converted hearse inherited from Ted's other business as a funeral director. Corpses in coffins often accompanied deliveries. Ted and his son had also made a line of wooden toys: Meccano sets, Hornby railways, Dinky Matchbox and Corgi toys were all popular.

Ted Meller died in 1951, yet the shop continued to prosper. The company was sold to Lines Bros of London in 1959.

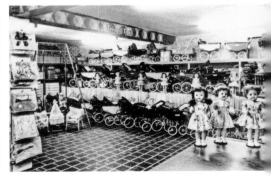

Inside and outside of Meller's Dolls Hospital.

Cuttriss Model Shop

Another great model shop, Cuttriss' was a veritable modelling enthusiasts' paradise piled high with Hornby railway sets, Airfix models as well as car kits and a plethora of other amazing toys.

Above: Cuttriss Model Shop.

Below: Greaves Furniture Shop.

Smithson, gunmakers.

Archibald Ramsden – Piano People

Archibald Ramsden at No. 24 High Street did good business with The Wonder Piano at 19*s* cash or 12*s* 9*d* a month. This piano boasted 'a full round tone in contrast to the thin common tone usually sold at this price'.

You could, however, spend up to £200 on a German grand, and choose from a range of 1,000 in stock at Archibald's Leeds or Doncaster warehouses. Archibald Ramsden made around 800 pianos between 1880 and 1920. Competition came from R. J. Pillin of St Sepulchre Gate.

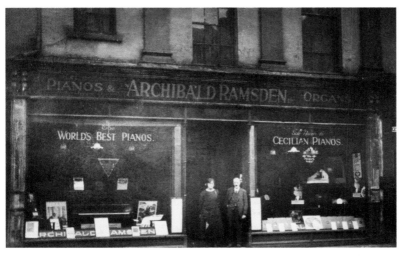

Archibald Ramsden, organs and pianos.

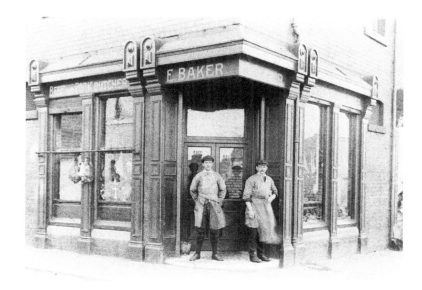

Baker's the butchers.

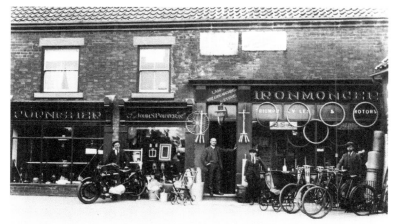

John Porter, ironmonger.

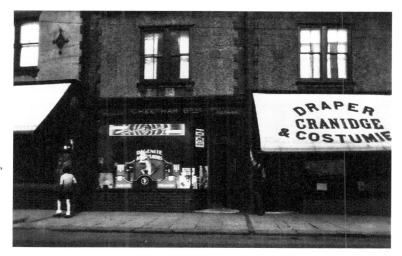

Cheetham Brothers, Dagenite battery dealers, and Cranidge, drapers and costumiers, on Soper's Corner.

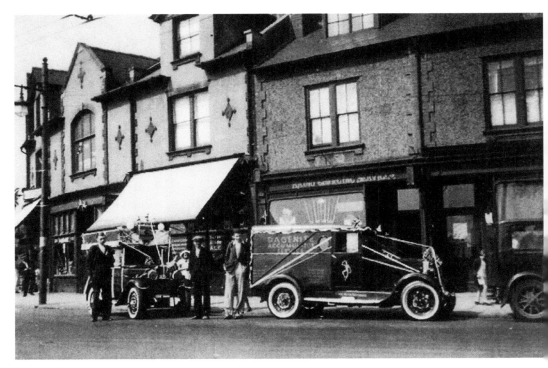

Above and left: Advertising Dagenite Motor Batteries on Arksey Lane Corner.

Northern Zoological Stores
Live animals galore at this popular pet shop – a town centre zoo – where most children crowded in simply to gaze at the pets without buying anything at all. Ranks of tanks of goldfish and a talking parrot made everyone's day.

Beetham's, Wine and Spirit Merchant
On Baxter Gate/St George Gate corner from 1826, Joshue Beetham merged his George & Dragon Vaults with this to form Beetham's pub. Whitbread bought the pub and renamed it the Gatehouse in 1986.

Beetham.

Doncaster Co-op.

Doncaster Co-op
The Doncaster Mutual Co-operative Industrial Society Ltd was on the corner of St Sepulchre Gate and Duke Street. In 1950 there were forty-four Co-op stores within 15 miles of this one, the number later rising to sixty-eight. A new Co-op opened in 1938 opposite the original, which was originally called the Emporium but later changed in the '70s to Danum House. There was a ballroom on the third floor where acts such as Johnny Dankworth and Cleo Laine performed.

Doncaster Market
Markets in Doncaster go back to Roman times when the locals established a *vicus* outside the walls of the Roman fort to trade with the garrison stationed there. Today's market is on that same spot and has, over time, benefitted from Doncaster being on the Great North Road. Doncaster was awarded its first official market in 1248, when a charter was granted for Doncaster's market to be held around the Norman Church of St Mary Magdalene.

Some 750 years on, the market continues to thrive, with its traders located both under cover at the nineteenth-century Corn Exchange building (1873) and in outside stalls. The Corn Exchange was extensively rebuilt in 1994 after a major fire. Doncaster can boast some 400 shops, stalls and stands.

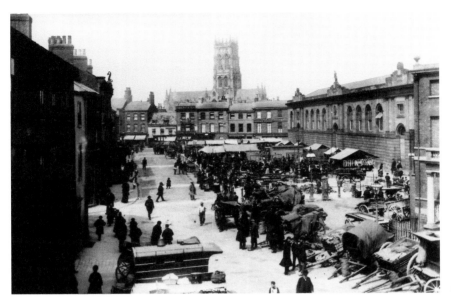

Doncaster
market.

SHIPBUILDING

Dunston

The fact that Doncaster, or more specifically Thorne, some 12 miles to the north-east, is landlocked did not stop the area from developing a shipbuilding industry. This was made possible by its position east of the River Don on the Stainforth and Keadby Canal. Even before the canals were dug in 1797 ships were being built at Thorne Quay on the River Don; in 1820 a paddle steamer named Rockingham was built to carry goods and passengers from Thorne to Hull. This was the first steam vessel built in the Humber district, and must have been one of the earliest steamships in Great Britain. Wooden vessels, both sailing and steam, were built up to 1890, when this shipyard closed down because of the silting up of the river and the building of bridges over the Don.

It was in 1858 when Richard Dunston, shipbuilder, started building wooden barges on the bank of the Stainforth and Keadby Canal. His self-sufficient shipyard made all of its sails, ropes and running gear and the Thorne ropery developed into quite an independent industry of its own supplying coir, hemp, manilla and cotton ropes to the surrounding country. The ships' chandlers of Hull and Grimsby used Dunston's as their principal source of supply for ships' blocks, masts, spars, boat hooks, boat oars, sails and covers. In 1932, Dunston's acquired the shipyard of Henry Scarr Ltd, of Hessle, where vessels with no dimensional limitations could be launched directly into the River Humber.

After 1932, Dunston's built 1,358 vessels at the Thorne yard and 636 at Hessle. During the Second World War the firm built 159 all-welded steel TID class tugs for the Admiralty, 152 at Thorne and seven at Hessle, with one completed ship leaving the shipyard every six days. Sections were fabricated elsewhere by companies with spare welding capacity, and were brought to the yard by lorry. Many of the Thorne shipyard welders were women.

In 1974 the Dunston family sold both yards to the Ingram Corporation of America. In 1985, they were put up for sale again, but the Thorne yard closed as it was not financially viable.

Dunston (Ship Repairs) Ltd survives at Hessle.

Thorne Lock and shipyard around 1900. (Picture from original photo held in the Dunston Archive)

SMALL BUSINESS

Doncaster and Balby Steam Laundry

The company, owned by Messrs Gardom & Whaley, worked out of a former girls' reformatory west of Balby Bridge.

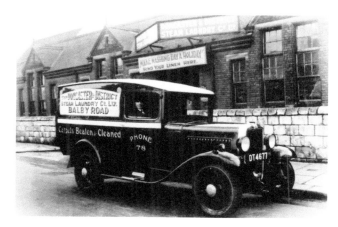

Doncaster and Balby Steam Laundry.

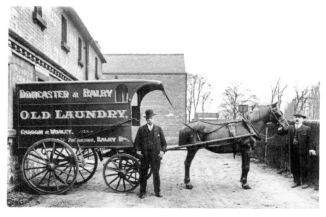

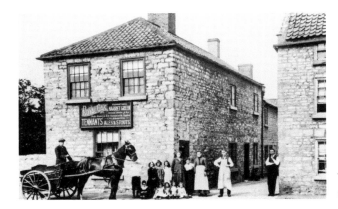

The Royal Oak under Harriet Green.

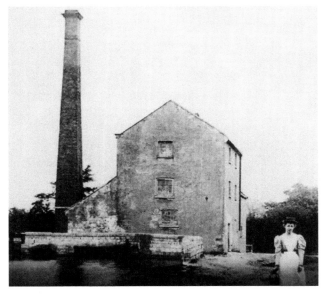

Bentley Water Mill, 1890.

Slack's Mineral Water Co. Ltd
Their mineral waterworks were in Balby. Other products they produced included Doncaster Ginger Beer.

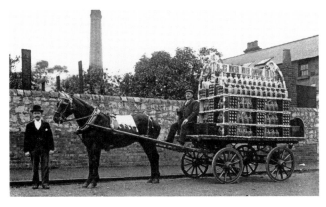

Slacks Mineral Water Co. Ltd.

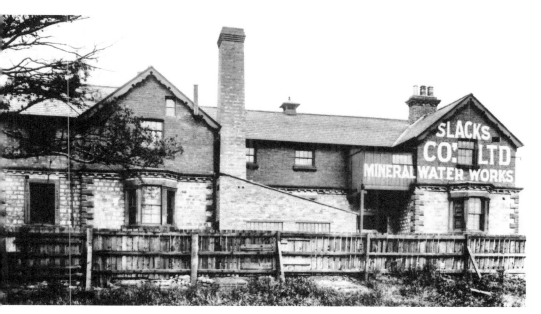

Slacks Co. Ltd.

Peat

Peat was big business around Thorne and Hatfield where each summer scores of women would break their backs stacking and turning acres of peat. This went on until the 1980s when the women were automated out of their seasonal work.

Women peat workers in the fields in 1953.

TOURISM AND LEISURE

THE RACES

I t all started around the sixteenth century when Doncaster was at the centre of the lucrative stagecoach trade. This led to horse breeding in Doncaster, which in turn led to the start of horseracing. The earliest important race in Doncaster's history was the Doncaster Gold Cup, first run over Cantley Common in 1766. The Doncaster Cup is the oldest continuing regulated horse race in the world. It started ten years before the St Leger and was run over a distance of 4 miles.

Doncaster Town Moor has hosted horse racing from the days of James I. It started to be formalised with the construction of permanent buildings and regular race meetings in the eighteenth century. The year 1776 saw the birth of the St Leger Stakes, named after Anthony

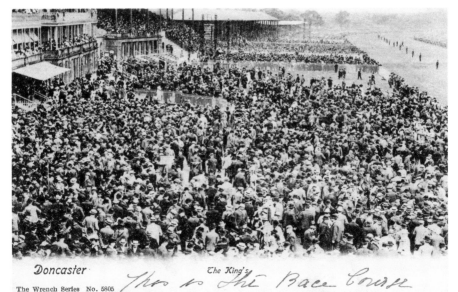

Doncaster

The King's

Thro to the Race Course

The Wrench Series No. 5805

A day at the races in 1925.

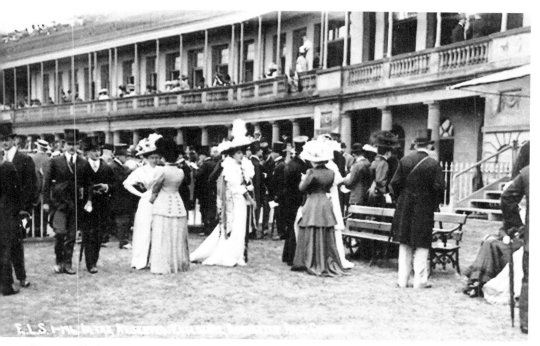

Above and below: Well-healed racegoers in the Reserved Enclosure.

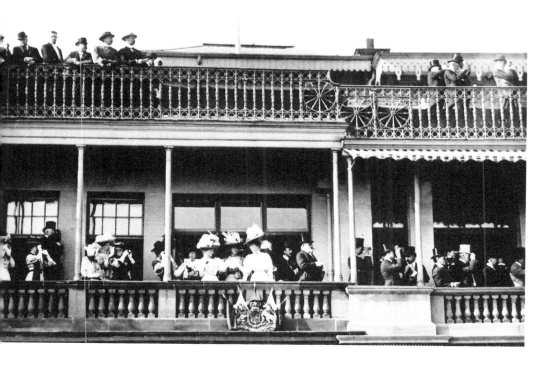

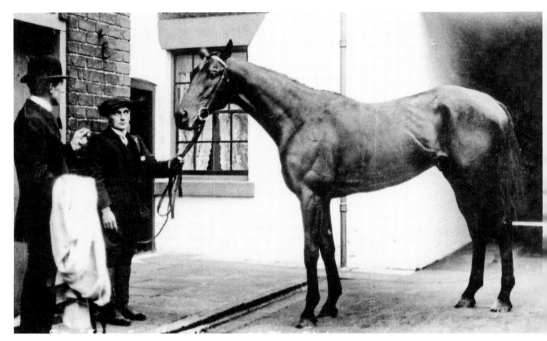

Never look a gift horse in the eye: Swynford, winner of the 1910 St Leger.

St Leger, Esq, of Park Hill, Firbeck, who dreamt up the race in which five horses ran. This has endured as Doncaster's major race ever since, and the annual early September race meeting is known as St Leger week.

Wealthy race visitors could take part in specially organised hunts at this time of the year, and cockfighting and bull-baiting attracted people from a wide variety of ages and social backgrounds. Gambling was, of course, very popular, and for the super-rich there was an off-course gambling salon near the Mansion House – the Subscription Rooms. Evenings topped off this major social and sporting event with dinners and balls, concerts and theatre. All of Doncaster society benefitted economically from this major tourist event.

The years 1777–78 saw Doncaster Corporation build the elegant Grand Stand to the design of much-sought-after John Carr of York. It accommodated 1,200 (wealthy) spectators near the winning post and was enlarged in 1824. The Judges' and Stewards' Stand was erected in 1805, and in 1823 the Publicans' Booths went up for ordinary racegoers to enjoy the forty-two booths there for the sale of alcohol, let to local publicans.

From the mid-nineteenth century the railways got involved in bringing the crowds to the racecourse. St Leger Day in 1935 saw thirty-two specials arrive from the north, mostly full of miners, and twenty down specials from the south carrying numerous aristocracy. These special trains were in addition to the packed ordinary services.

In 1992 Doncaster hosted the first ever Sunday meeting on a British racecourse. A crowd of 23,000 turned up despite the fact that there was something missing – betting. Today the St Leger Stakes remains the world's oldest classic horse race and features in the horse racing calendar as the fifth and final Classic of the British flat racing season.

DONCASTER AT WORK IN THE TWENTY-FIRST CENTURY

Much of Doncaster's twenty-first-century work revolves around its pre-eminence as a distribution hub.

LOGISTICS HUB UK

At the centre of this the hub are Doncaster Sheffield Airport and iPort, a £300 million strategic logistics space that, when complete, will provide 6 million square feet of warehousing and a 35-acre rail freight interchange.

Logistics Hub UK is already home to national and regional distribution centres for Asda/Walmart, BMW, IKEA, Next, Unipart, Tesco, Lidl and Amazon with its 1.1 million mega-shed, giving them unrivalled access to domestic and international markets. Logistics Hub UK is located at a central hub in the UK's motorway network, providing direct access to the M1, A1(M) and M18 north–south motorways, and the M62 and M180 east–west motorways.

It delivers return journeys to all major UK-mainland markets within one HGV driver shift; same-day deliveries to major markets in both southern England and central Scotland; and access to all major population centres and markets in England within three hours and thirty minutes, England and Wales within four hours and England, Wales and Scotland within four hours and thirty minutes.

IPORT RAIL, DONCASTER

The UK's newest intermodal inland rail freight hub is now open and fully operational. Located on a 30-acre site within the 337-acre iPort Logistics Hub, iPort Rail is a state-of-the-art rail freight facility able to accommodate the UK's longest trains up to six times a day. It has storage capacity for 1,500 TEUs and a reach stacker operation with a 115-ton front axle load. The site connects to the East Coast Main Line.

Rail freight is destined to play an increasingly important part in the supply chain over the next decade: one train can replace 60–70 HGV movements with only a quarter of the carbon emissions.

CONISBROUGH

THE KILNER COMPANY

Conisbrough's industrial history starts with the Kilner Company: on 1 December 1844 John Kilner began to make glass bottles at Thornhill Lees. In 1864, George Kilner, one of the four brothers who inherited the business, and father of Caleb Kilner, founded the Conisbrough branch at Kilner's Providence Glassworks at Denaby Main. The Kilner family had established several glassworks across the north of England during the nineteenth century including Castleford, Wakefield and Thornhill Lees, and by 1871 they employed 123 men at

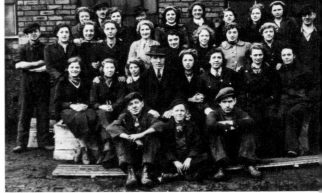

Above: Workers in the early 1900s.

Left: A famous Kilner jar from 1928 containing cornflower. Kilner jars were typically rubber sealed, screw topped and used for preserving (bottling) food.

Conisbrough/Denaby. By 1894 they employed 400 men, women and boys, and were making up to 300,000 bottles of all types per week.

We learn from Grace's Guide that 'The bottles made at Conisbrough are chiefly mineral water, spice, confectionery, wine and spirits, pickle, medicine, and chemist and druggist bottles of all descriptions.' In 1866, business genius Caleb Kilner was sent to manage Conisbrough, along with his cousin Kilner Bateson.

A separate department of fifteen or so women existed for grinding marbles or glass balls to be inserted in the patented and internal stoppered bottles. There was also a large smith's and machine shops for repairing the blow pipes, moulds and steam hammers. It contained six fires, the steam hammer, lathes and drilling machines. The mould store had 3,000 plus different moulds. The Kilner Company employed something like 1,000 people at their various establishments, with 500 or so at the Conisbrough works. The firm provided seventy-six cottages for their workers.

In 1871 the Kilner Company was taken to court over the coal smoke spewing from their Thornhill Lees chimneys. The judge ordered that 'no man has the right to interfere with the supply of pure air'. The company was forced to close down in order to convert to gas furnaces.

In 1937 the Kilner Company went bankrupt. Rights to the Kilner Jar product line were sold to the United Glass Bottle Manufacturers that same year.

THE ELTSAC TOFFEE WORKS

The Eltsac Toffee Works (that's [Conisbrough] castle backwards) was a successful confectioners in the early twentieth century. This is the story of Bosdin J. Clarkson, founder of the firm, which was adapted from 'The Art of Sweet Making' and published in the *Mexborough Times*, 17 December 1910.

The history of Mr Clarkson's confectionery and bakery works is the history of Mr Clarkson himself. He was the youngest of a large family, and was born at Braithwell, 3 miles from Conisbrough, in 1859. The youngest son of Mr William Clarkson, a hosiery manufacturer, he was only six weeks old when his father died. Aged thirteen, he was apprenticed to Mr. Charles Kenyon, confectioner, jam manufacturer and baker, at Rotherham. In 1880 at the age of twenty-one, he was a qualified baker and confectioner. Released from his indentures, he went

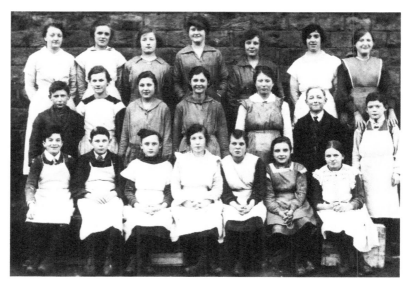

Workers in
the 1920s.

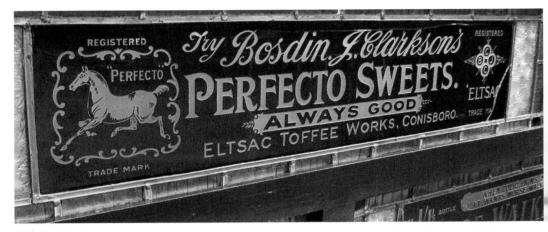

This beautifully crafted glass tram advert was photographed at Crich Tramway Village, Derbyshire, 'a lovingly restored period village that is also home to the National Tramway Museum', by Angela Montague, 16 August 2010.

to Conisbrough and started working in the same line of business for a William Allen, from whom he bought the business after six months.

In 1885, Clarkson built the factory in Doncaster Road, having abandoned the Little Brook square workshop. As time went by he developed his business strategy and became alive to the possibilities of his sweets, his bread and cakes. He duplicated his sugar boilers, added steam power, and introduced up-to-date hot air ovens for baking. By 1910 he had forty-four people on his books.

In 1892, Clarkson bought a farm of 135 acres – now the source of all his milk and butter. Popular products included sugar fishes, liquorice rock, Eltsac toffee, multum in parvo sweet, rum and butter toffee and pink dainty cachu. (www.conisbroughanddenabyhistory.org.uk/article/eltsac-sweetmaking-in-conisbrough/)

THE HOLYWELL BREWERY

The census for 1841 records that the company's founder, Joseph Nicholson, is a maltster aged thirty and lives in White Leather Alley. Joseph Nicholson and Charles Hammond Thompson owned the future brewery premises in 1854 when it was a flax mill. By 1857 Joseph Nicholson was the sole owner and in 1859 converted the mill to a brewery, Holywell Brewery. The first public house supplied by Holywell was The Red Lion Inn on Sheffield Road in Conisbrough.

On 17 August 1874 Mr John William Nicholson was charged with polluting the Conisbrough Brook 'by allowing deleterious matter to flow from his brewery into it'. Mr Nicholson was ordered to abate the nuisance within six weeks. On 24 August 1896 an application was made by Mr G.T. Nicholson of Conisbrough Brewery for a beer dealer's additional retail license. 'The applicant wanted to sell bottled beer to farmers. The application was opposed by local licensed victuallers. The Bench granted the application on condition that there should be no hawking and that not less than one dozen pints or two dozen half pints should be sold to order.'

After 1880 the business was run by George, one of his sons. The numbers on the payroll increased as the output went up and the reputation of Holywell Beers spread. In 1905 the brewery and bottling business was acquired by Whitworth, Son & Nephew, brewers of Wath-upon-Dearne. The Holywell Lane premises were subsequently taken over by the

Holywell Brewery, a former bobbin mill later occupied by the XL Crisp Company until the 1950s.

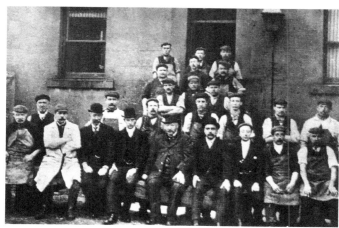

Holywell brewers.

XL Crisp Company until the late 1950s when a new factory was built. The maltings on the opposite side of Sheffield Road were later occupied by Braim and Cooper fat works. (Much of the above is paraphrased from 'Photographs of Old Conisbrough' by June and Tony Greathead – http:// www.conisbroughheritage.co.uk/Holywell%20Brewery.html)

OTHER LOCAL INDUSTRIES

Hill Top Brewery
Charles Thompson of Holywell Brewery built the Hill Inn and Brewery around 1825. His widow married Francis Ogley in 1828, who built the present Hill Top Hotel around 1870. The original inn was on the opposite side of the road.

The Sickle Works
Originally a cannon-boring mill, this works then went on to make sickles, which were exported all over the world. It all started in 1821 when John and Thomas Mullins of Birley Hey relocated their machinery from Skelfer Forge in the Ford Valley to the Conisbrough Mills where they worked for some twenty years. The Mullins were succeeded by William Linley,

who in 1849 is described as a manufacturer of scythes, sickles and hooks at Conisbrough Mills. In 1861 Thomas Booth & Sons were running Conisbrough Mills as timber and coal merchants, woodturners and manufacturers of brushwork, cask staves, hooks and sickles.

In 1869 Thomas Booth Snr died and the business was split between his sons: Thomas Booth Jnr as woodturner, brush manufacturer, timber merchant and coal dealer at the old mills, and George Booth & Sons as hook, sickle and machine knife manufacturers at the Conisbrough Steam Mills. It made nearly half a million sickles a year, and exported more than 85 per cent of them. There were export markets in Cuba, Jamaica, Barbados, Trinidad, New South Wales, Canada, Penang, Ceylon, the South Sea Islands and Zululand. The firm was the only business in the world that made the whole sickle, handle and blade.

In the 1950s the business was acquired by Thomas Staniforth & Sons of Hackenthorpe, which became part of Spear & Jackson in 1967. In 1976 the business was closed down.

The original cannon boring works supplied eighty canon for Nelson's *Victory* at Trafalgar (1805).

Workers at the factory consigning sickles to Bolivia in 1940 while listening to a BBC programme about the history of the company.

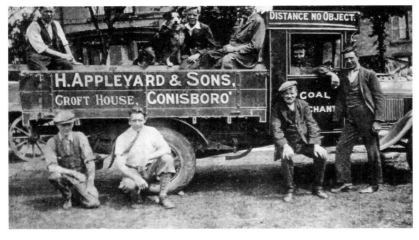

H. Appleyard & Sons, coal merchants.

The Bone Mill

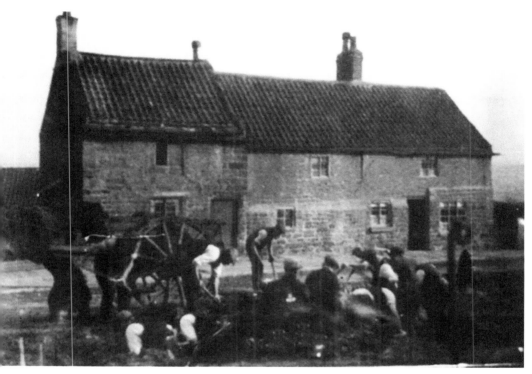

Bone Mill Cottages.

Conisbrough Brickworks

The South Yorkshire Times of 26 March 1926 reported 'Last week, Thursday, 69,000 bricks were sent out of Conisbrough Works and over 63,000 on Friday. A new continuous kiln is nearing completion'.

Conisbrough Sawmill

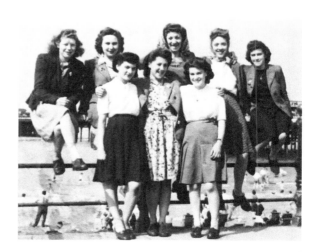

Women workers on a works trip to Blackpool.

XL Crisps

XL Crisps.

One hundred and fifty workers lost their jobs on 3 January 1975 when the Conisbrough crisp factory ceased production. The plant had been losing money because of the increases in the price of palm oil – it had gone up 200 per cent since March. Half a pence on a packet of crisps could not stop the shutdown.

The factory was established in Conisbrough in 1949 by the Gaffney family from Thorne. Mr K. Gaffney had a fish and chip shop in North Eastern Road, Thorne, which he took over after war service. The Conisbrough factory had produced about 2 million packets of crisps a week.

Denaby Main Powderworks

It began trading in 1889 as The Flameless Explosive Company on Denaby Lane; The company was tasked to manufacture 'Securite', which had special properties that superceded gunpowder or other materials used for blasting operations in mines. The workforce consisted of crimpers, testers and numberers. Over-18s graduated to the more dangerous detonator shed. Huge rolls of wire were cut by a mainly female workforce and thousands of detonators were primed and prepared for use.

The Powderworks contributed to the war effort by making small bombs in the First and Second World Wars. In the First World War the works became the British Westfalite National Trench Warfare Filling Factory, and Denaby Main was set up by the Ministry of Munitions and operational by Westfalite Factory staff from February 1916. The factory was largely staffed by women and girls filling Stokes mortar shells.

Employees had in the early days to 'divest themselves of their ordinary attire and assume woollen garments specially made and supplied by the company'. The regulations in force were to be of 'the most stringent character, although only the remotest danger is to be feared and a catastrophe can only be brought about by the most gross carelessness'. Accidents did happen over the years, but none of any great consequence. Many girls who worked 'in the powder' developed yellow-stained hands and faces.

Management was nothing short of enlightened by the standards of the day: from the 1900s staff were provided with social facilities including a bowling green, two tennis courts and a recreation room with table tennis tables and a reading room. Protective clothing was laundered for the workers, there was a nurse who dealt with minor ailments and injuries, a works canteen and lunchtime concerts, by the 'Workers Playtime' radio programme. On reaching twenty-one, employees could join a pension scheme, benefit from a savings bank and receive shares. From the 1920s a committee made up of management and workers met regularly to advise on the day-to-day running of the plant.

The firm was later bought by ICI. Two hundred and fifty-one men and women lost their jobs when it closed in 1963.

Victoria Glassworks

The Victoria Glassworks was opened in Kilnhurst in 1855 by the Blunn family, who already had a successful glass-blowing factory in Catcliffe near Rotherham. The works was on Glasshouse Lane near the pottery. They produced medical glass bottles; soda water, ginger beer, wine and pickle bottles; and dram ovals and flasks. They closed in 1906

John Baker & Co., Kilnhurst

Kilnhurst had ironworks from the fourteenth century, and in the seventeenth century a forge was constructed. Around 1722 navigation on the River Don was improved and a weir was built near Kilnhurst Bridge, so that water could be diverted into a stream serving the forge.

A John Cockshuttle took over using a new process of making wrought iron, and a new puddling furnace was installed around 1790. It continued to operate during the nineteenth century but closed in 1883. The Swinton Iron works changed hands several times in the nineteenth century before being taken over by John Brown & Co. in 1863. A large plant was built for puddling iron for armour plate for battleships, but steel superseded iron later in the century. The building was derelict in 1901, but the site was bought in 1902 by John Baker and developed by his sons after their father's death in 1904, producing railway wheels and axles.

In the First World War, like many other steelworks during the war, John Baker & Co.'s Kilnhurst site was converted to make shells and ammunition, and the company produced over 6 million shells. As men volunteered or were conscripted to fight in the army, women became the main workforce in industry and farming. Munitions workers, munitionettes, could often be spotted in a crowd because of the distinctive yellow colouring of their hair and skin caused by the sulphur used in TNT production. They were nicknamed canaries. In the South Yorkshire steel industry the number of women employed increased six fold. To record this, Baker commissioned a painting: *The Munitions Girls* from Stanhope Forbes (1857–1947). George Baker remarked that 'The primary object of the picture was to produce a memento for our women workers, and each of them received a framed copy of it'.

In the foreground two girls are shown pushing a trolley loaded with 4.5 inch shells, while in the background there are dozens of others forging, operating furnaces and the like. In 1983 the London Science Museum bought the painting for £17,840, and it now hangs in their Iron and Steel Gallery.

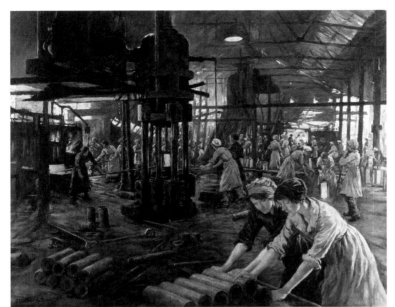

Left: The Munitions Girls. Commissioned by John Baker & Co., this famous 1918 oil painting shows women working at Kilnhurst Steelworks during the First World War.

Below: Baker's Forge, Kilnhurst.

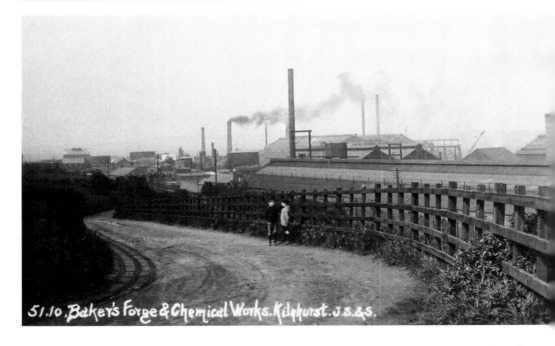

In 1927 in an expansion drive the company took over Harrison and Camm Ltd, lured by its 4,000-ton wheel press. Expansion continued when in 1932 the company took over Henry Bessemer Ltd and became Baker and Bessemer Ltd. During the Second World War munitions were once gain in demand. The factory was producing shells, aircraft catapult pulleys, armour-piercing nose caps, anti-aircraft rocket bodies and bogie wheels for the Churchill tank.

In 1963 the company was acquired by United Steel Companies Ltd and English Steel Corporation. The Kilnhurst plant was closed down and 1,000 workers lost their jobs.

Ellison & Mitchell Ltd/Yorkshire Tar Distillers Ltd

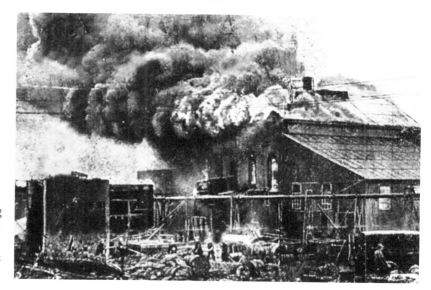

The devastating fire at Ellison & Mitchell chemical works in 1918.

This began when founder Henry Ellison of Cleckheaton purchased 4 acres of land in 1886 in order to open a tar distillery. Ellison & Mitchell Ltd continued until 1927 when the premier the important tar distillers in Yorkshire amalgamated to form the Yorkshire Tar Distillers Ltd.

Conisbrough Viaduct

The majestic Conisbrough Viaduct on the Deane Valley Railway (Wakefield to the south of Doncaster) was built in 1907. Spanning the Don Gorge for the L&YR, it is an impressive 1,525 feet long, 113 feet high and has twenty-one blue Conisbrough brick arches. Essentially it was a line which served a coalfield, although there was a basic passenger service between 1912 and 1951. What was left of the coal traffic on the line ended in 1966. The viaduct was redundant until 2001, when ownership was transferred to Railway Paths Ltd.

Conisbrough Viaduct.

SOME SMALL BUSINESSES

J. Drabble's shop in Conisbrough.

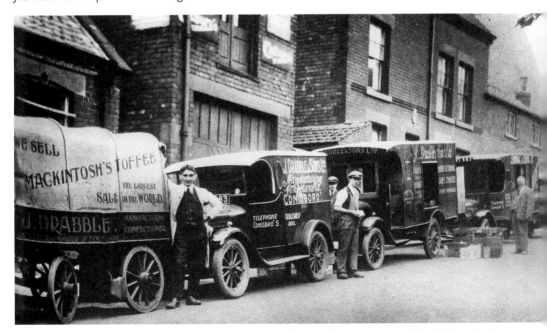

Looking towards Old Road from West Street and Church Street junction. Established by Joss Drabble and brother-in-law John Maxfield in 1890, Doreen Drabble later took over. The firm closed in 1981. Next door is H. I. Ogilvy, plumber, glazier and gas fitter.

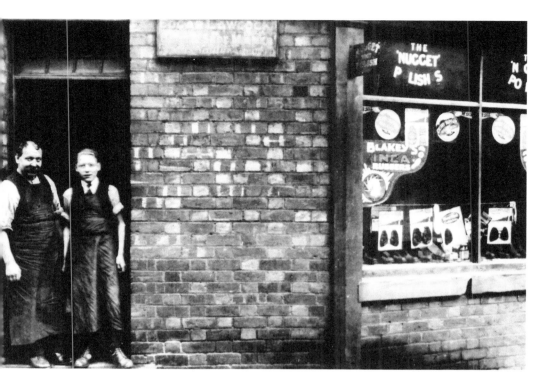

Edgar Laycock, boot and shoe maker.

MEXBOROUGH

Eighteenth-, nineteenth- and most of twentieth-century Mexborough was industrially and economically dependant on coal mining, quarrying, brickworks and the production of ceramics and glass bottles; it also became a busy railway junction.

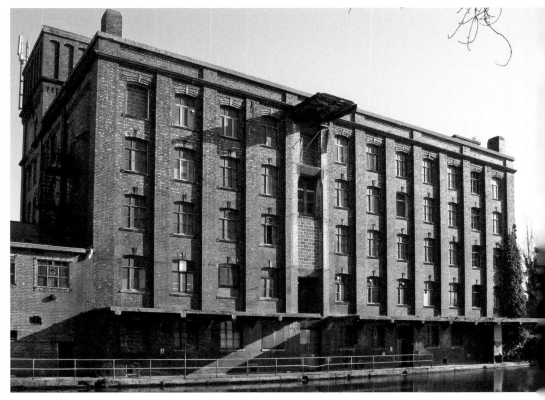

The former BCCS bakery. This stands on the north side of the Don Navigation. It started life as the 'Don Roller Mills', owned by James White, who sold it to the Barnsley British Cooperative Society in 1912.

Some local businesses and industry:

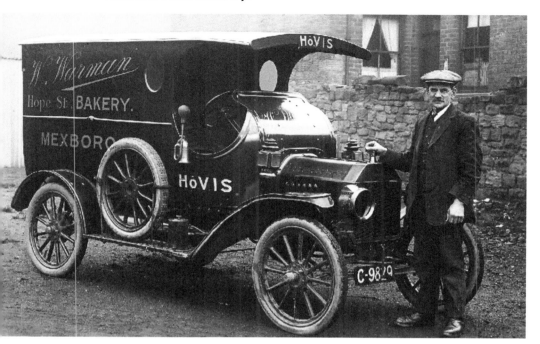

W. Warman, bakers, with a delivery van.

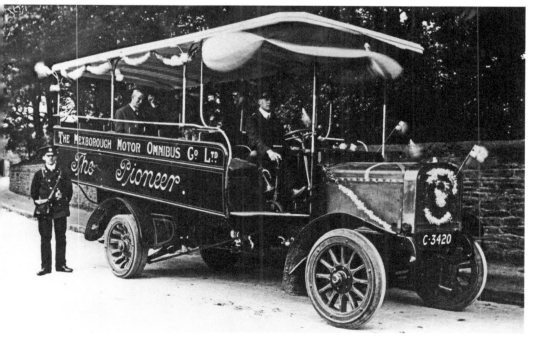

An omnibus from the Mexborough Motor Omnibus Co. Ltd, decorated for coronation day celebrations, 22 June 1911.

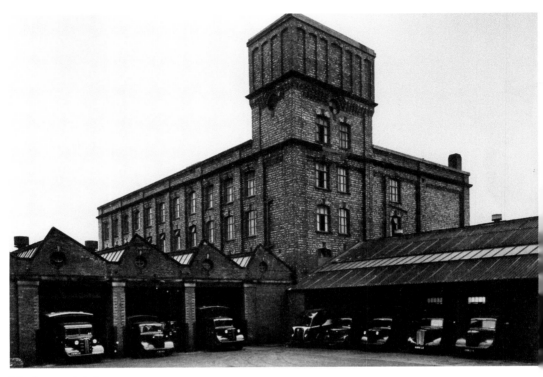

Mexborough bakery.

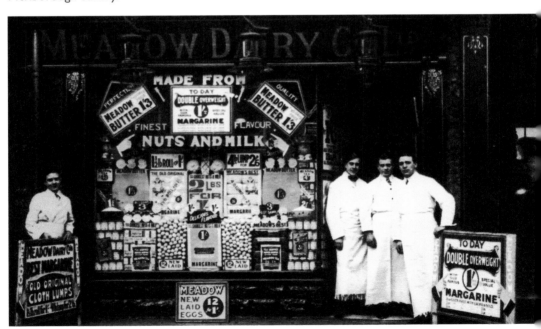

Meadow Dairy, Goldthorpe.

The Electric Light Works.

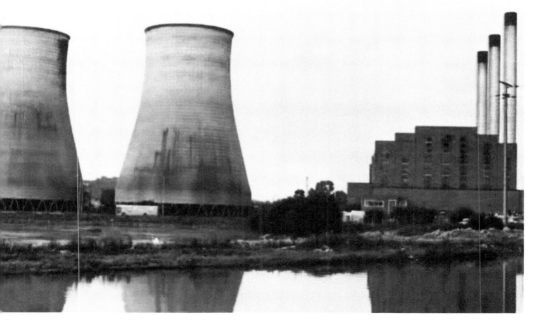

The twin cooling towers of Mexborough power station, demolished in 1988.

CERAMICS

If any one industry defined Mexborough it was ceramics. Mexborough can claim to be the home of three major potteries of national as well as of local interest: the Rockingham Pottery; the Don Pottery, Swinton; and Mexborough Old Pottery were the most significant.

Rockingham Pottery
Located at the junction of Blackamoor Lane and Warren Vale Road, it was originally known as the Swinton Pottery. In 1745 John Flint was in charge, running the pottery there on land owned by the Marquis of Rockingham – hence the name. In 1753 Edward Butler worked local deposits of red and buff clay to produce wares that can only be described as rough and crude earthenware product. However, 1765 saw production of a finer type of pottery when William Malpass and William Fenney bought the works and switched to local white pipe clay, flint from the coast, and ball clay from Devon. The name changed to Bingley, Wood & Co. and in 1787 it was taken over by the Leeds Pottery.

In 1806 this changed again when John Brameld and his son William – Leeds Pottery workers for many years – started making pearl and stone china decorated with unglazed transfer prints stamped with the trademark 'BRAMELD'.

By 1819 the works was in trouble due to a debt of £22,000 caused by the Napoleonic Wars. The Brameld family approached Earl Fitzwilliam, who agreed to cover their debts.

By the next year Thomas and John Wager Brameld experimented with making soft-paste porcelain and by 1825 they were producing it on a commercial basis. In 1826

An 1831 piece of Rockingham Pottery.

A Rockingham
porcelain
basket.

the Swinton Pottery changed its named to the Rockingham Works in honour of the Earl Fitzwilliam, who inherited his estate from his uncle, the Marquis of Rockingham. To show the world the expertise and craftmanship residing in the pottery a huge vase was made, 45 inches in height and weighing 100 lbs. At the time it was the largest piece of English porcelain to be fired in one piece and became known as the Wentworth Rockingham Vase.

Isaac Baguley moved from Derby to work for them. In 1830 William IV ordered a 200-piece dessert service. No expense was spared and little if any profit was made but it lent Rockingham a priceless reputation as suppliers to the king and opened up a market from the aristocracy and the emerging middle classes. Orders flowed in for vases, ewers, scent bottles, potpourri vases, and baskets with modelled flowers on them, all gilded and enamelled in radiant colours.

Earl Fitzwilliam died and was succeeded by his son and in 1841 when the Brameld family approached the young Earl Fitzwilliam the money was not forthcoming, as he was sinking his wealth pits and canals. The Rockingham Pottery was advertised for sale in the *Sheffield Iris* on 31 December 1842.

Brameld Pottery

It wasn't all elegance, gilt and finery. The Bramfelds also made pottery for everyday use, bearing transfer prints of the willow pattern, the woodman returning home, the Castle of Rochfort, exotic birds and insects in twisted trees, and the adventures of Don Quixote. Later their pottery was distinguished by a rich brown or green glaze.

Swinton Bridge Pottery

Somewhat obscure, we know that it started operating around 1830.

The Don Pottery

The Don Pottery was set up in 1801 by John Green on the banks of the South Yorkshire Navigation Canal.

When in 1800 John Green, the managing partner of the Swinton Pottery, went bankrupt he, with his partners Richard Clark and John and William Brameld of the Swinton Pottery, opened a new pottery under the name of Green, Clark & Co. This pottery was called the Don Pottery.

In 1810 the firm changed its name to John & William Green & Co. or just Green & Co., but by 1835 the Don Pottery was declared bankrupt and was sold at auction. The pottery buildings themselves were bought by Samuel Barker, who also owned the Old Mexborough Pottery. For a number of years he ran the two potteries as one concern until 1844 when the Old Mexborough Pottery ceased production and in 1848 converted it into an iron foundry, which went by the name of the Don Iron Works.

In 1857 Samuel Barker's three sons joined the surviving pottery, which traded under the name of Samuel Barker & Son until 1882.

The Don Pottery.

Above left: An earthenware jug with a bluish glaze, it is decorated with black transfer prints over the glaze painted in colours. Both sides show a large man waving a hat, and the front of the jug has an inscription. The rim and edges of the handle are lined with dark red. Dates to around 1810. (Courtesy of Yorkshire Museum Trust under CC BY-SA 4.0)

Above right: A hand-painted piece of Don Pottery.

The Mexborough Old Pottery

Situated on Cliff Street on the banks of the South Yorkshire Navigation Canal, it was established at the end of the eighteenth century by Robert Sowter and William Bromley, who traded under the name of Sowter & Co., producing high-end pottery.

The year 1804 saw the Mexborough Old Pottery purchased by Peter Barker, who had previously been the manager of the Swinton Pottery. In 1809 he and his brother, Jesse, were succeeded by Samuel Barker, son of Jesse Barker.

Emery's Pottery

Located at the junction of High Street and Garden Street, this pottery was turning out goods from around 1838 to 1886.

Output was largely novelty items in decorative pearl ware for ornamental purposes. The most popular were grandfather clocks, 9 inches in height and trimmed in puce, yellow, green, blue and brown, sometimes with figures with them. The hands of their clocks always said 6 o'clock and they are marked on the back with 'J. Emery/Mexboro'.

The Rock Pottery

Situated to the north of Bank Street, this pottery was so named because the back walls of the workshops were part of a rocky outcrop.

In 1839 it was owned by Reid & Taylor [*sic*] Manufacturers, who also owned the Coalfield Brickworks. In its early days it traded as Beevers & Ford and was purchased in 1839 by James Reed, whose son, John Reed, changed its name in 1849 to the Mexborough Pottery. When the Rockingham Pottery closed John Reed bought most of their moulds and produced many items from them with differing transfer prints – plain green with raised leaf design impressed with 'Reed'. Rock Pottery is famous for its many commemorative money boxes that are made in the shape of churches or chapels.

John Reed died childless. In 1873 the pottery was purchased by Sydney Wolf of the Ferrybridge Pottery. It closed in 1883.

The Denaby Pottery

The Denaby Pottery was on the banks of the Don near to the site of Denaby Colliery, and set up mainly to produce fire bricks. However, in 1864 it was taken over by John Wardle, a Staffordshire potter and his partner Charles W. Wilkinson. In 1870 the pottery closed. Their output had been everyday items of printed earthenware, although more elaborate pieces have been found including an enamelled pearl ware jug and a brown glazed earthenware money box in the shape of a toll bar house.

When the pottery closed, the buildings were given over to the production of bone meal and glue and towards the beginning of the twentieth century they were taken over by George Lunn of Old Denaby as a depot for his dairy.

Milton Pottery

Built in 1902 at Skiers Spring Colliery, where Stead Lane enters Skiers Spring Wood, south of Hoyland, the pottery included buildings for throwing and drying pots and a large kiln capable of firing 3,000 pieces. The pottery employed eight men and made plant pots, kitchenware and other household items. It closed in 1937.

Newhill Pottery

Newhill was a small hamlet just south of Wath-upon-Dearne. In 1809 a local potter, Joseph Twigg, built Newhill Pottery, which at its height it employed between thirty and forty people, mostly women.

The relative calm of the pottery world was shattered when in 1827 Twigg was accused of theft by rivals, the Bramelds of Rockingham. Twigg was acquitted. The pottery eventually closed in 1873.

THE RAILWAYS

For the best part of a hundred years, the railway locomotive maintenance and stabling depot known as 'Mexborough Loco' was a major employer here. The South Yorkshire, Doncaster & Goole Railway set up in Mexborough in 1850 with a huge fifteen-road depot, which, at its height, handled around 150 locomotives. In the 1920s it was housed the LNER Garratt. The depot closed in 1964.

The London and North Eastern Railway Class U1 was a one off 2-8-0+0-8-2 Beyer-Garratt locomotive designed for banking coal trains over the very steep Worsborough Bank in South Yorkshire and part of the Woodhead Route. It was both the longest and the most powerful steam locomotive ever to run in Britain. Built in 1925 with the original number 2395, it was renumbered 9999 in March 1946, and then 69999 after nationalisation in 1948.

GLASS

The following is adapted from the *Sheffield Evening Telegraph*, 4 July 1887:

The credit for introducing the manufacture of glass bottles into the region is largely due to Mr. Thomas Barron of Glasshouse Lane, the head of the firm of Messrs. Thomas Barron and Sons, Mexborough. After time spent with Kilner Bros. Glassworks at Denaby Main,

Thomas Barron Ltd.

in 1850, Mr. Barron, with his father (Mr. Joseph Barron), his brother Joseph, Benjamin Rylands, John Tillotson, James Tillotson, and Joseph Wilson, glass blowers, decided to go into the glass business and set up in an old house which stood on the site where the Don Glass Works were, calling it the Don Glass Bottle Works.

The firm made mainly wine bottles; their average weekly output in the first two years was about 25,000 units. Benjamin Rylands, John and James Tillotson, and Joseph Wilson left the firm, and set up business at the Swinton Works, owned by the South Yorkshire Glass Bottle Manufacturing Company.

After nine years, Joseph Barron jnr left, taking with him the title of the Don Glass Works but it failed and was sold to, among others, Hartley Barron who was given a pay off and set up the Bull Green Glass Works, near Denaby. Thomas Barron changed his company name to the Phoenix Works. In 1883 he got wind of a more efficient way of producing glass – the Siemens Process invented in 1866 for the production of steel; in 1883 a start was made on the foundations for the chimney of the new furnace, and the production of glass by the "continuous system" of Siemens Process started in April 1884. By 1885 Barron employed three hundred men and boys.

ABOUT THE AUTHOR

Paul Chrystal has Classics degrees from the universities of Hull and Southampton. He then went into medical publishing for forty or so years but now combines this with writing features for national newspapers and history magazines, as well as appearing regularly on BBC local radio, on the BBC World Service and Radio 4's PM programme. In 2018 Paul contributed to a six-part series for BBC2 celebrating the history of some of Britain's most iconic craft industries, in this case chocolate in York. He has been history advisor for a number of York tourist attractions and is the author of 100 or so books on a wide range of subjects, including many on Yorkshire. He is a regular reviewer for and contributor to 'Classics for All'. From 2019 he is editor of *York Historian*, the journal of the Yorkshire Architectural and York Archaeological Society. Also in 2019, Paul is a guest speaker for the prestigious Vassar College New York's London Programme in association with Goldsmith University. Paul lives near York.

Also by Paul Chrystal
Whitby at Work (2019)
Bradford at Work (2018)
Cadbury and Fry Through Time
The Rowntree Family of York
The Confectionery Industry in Yorkshire
Chocolate: A History
York: Places of Industry
Coffee: A Drink for the Devil
Tea: A Very English Beverage
York and Its Railways
Old Saltaire
Pubs in and Around the Yorkshire Dales (2018)
Pubs in and Around York (2018)
Old Skipton (2019)
Old Sheffield (2019)
Old Wakefield (2019)